NASHVILLE

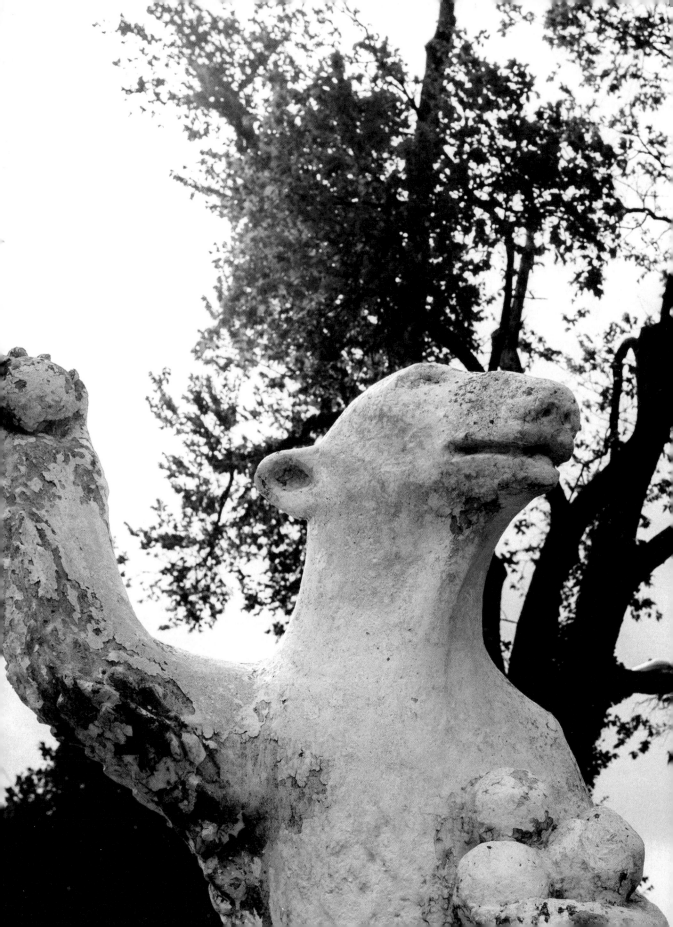

NASHVILLE

SCENES FROM THE NEW AMERICAN SOUTH

INTRODUCTION BY JON MEACHAM

TEXT BY ANN PATCHETT

PHOTOGRAPHS BY HEIDI ROSS

HARPER
DESIGN

An Imprint of HarperCollinsPublishers

CONTENTS

INTRODUCTION

JON MEACHAM

6

**THE FERRY TAKES US BACK
AND THE WINGS BRING US HOME**

ANN PATCHETT

12

PLATES

HEIDI ROSS

24

ABOUT THE CONTRIBUTORS

204

ACKNOWLEDGMENTS

206

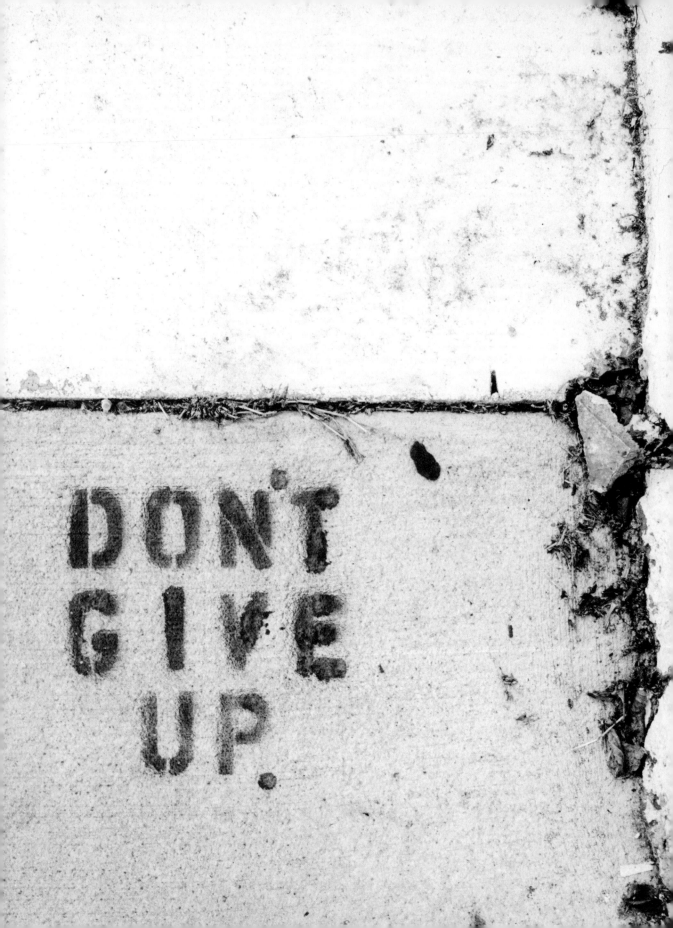

INTRODUCTION

It was an elegant evening. Outside a large columned house on Nashville's Belle Meade Boulevard in the middle of the second decade of the twenty-first century, the big green lawn darkened in an unseasonably warm Tennessee dusk, patrons of the city's vibrant public library sipped drinks and politely jockeyed for a moment with the guest of honor. They clasped his hand again and again, often reaching out to touch his shoulder; more than a few hesitantly asked for a picture, their faces lighting up when John Lewis said yes, of course.

So it went for a long cocktail hour: the elite of a once-segregated city paying unabashed tribute to perhaps the greatest living civil-rights champion, a man who had learned the craft and the power of nonviolence in the city's American Baptist College and Fisk University more than a half century before. Nashville was where he learned the patience to endure unimaginable hate—psychological and physical—for a larger cause. It was his bravery—in Montgomery, in Selma, in his words as the youngest speaker at the March on Washington—that helped lead to the end of Jim Crow. "Because

PAGE 2: The Polar Bears of Edgehill are as essential to Nashville as the Parthenon, the state capitol, and the Donut Den.

෫

PAGES 4–5: One of Adrien Saporiti's *I Believe in Nashville* murals.

෫

OPPOSITE: Graffiti on a Riverside Village street corner.

of you, John," Barack Obama wrote to Lewis on the occasion of Obama's inauguration as the nation's first African-American president. Lewis's first sit-in was to desegregate the downtown Woolworth's lunch counter here. "Nashville is where it all started," Lewis remarked quietly that evening at the library party. "The city has changed so much—so much. It's hard to believe, sometimes."

Lewis, a veteran congressman from Atlanta, was right: Nashville's current moment *is* hard to believe. But it's become an established fact, more a long-term reality than a civic fluke. The numbers are by now familiar: in 2016 Nashville moved ahead of Dallas and Austin on *Forbes's* Best Cities for Jobs list, holding the number-four slot nationally. Just Denver and Austin are expected to expand more rapidly in terms of population over the next decade. Roughly put, about eighty people move to the Nashville region every day. The school system is home to 120 different languages.

Such statistics are telling but fleeting. They'll change soon enough, either upward or downward. That's the way history—*life*—works. What won't change—for this is also how history and life work—is the moment itself. This book is testament to the reality of right now, a right now that has Nashville and its disparate people living in a kind of civic golden age. Yes, yes, I know: as Robert Frost taught us, nothing gold can stay. But that doesn't mean the golden age wasn't golden, and—to torture the metaphor a bit—there is utility, great utility, in being able to remind ourselves, in tarnished days, of brighter ones.

Heidi Ross has given us a great gift: a powerful visual record of a fascinating new hour in the life of an ancient place. Here are the places and the people—some of them, anyway—who have helped make Nashville a place people want to come to. And, when you think about it, is there really any better test for a city than to produce the kind of ethos that makes wayfarers long to be counted among its people?

Long the capital of country music—a red-state mecca before we called them "red states"— Nashville in the twenty-first century has realized the vision of its nineteenth-century fathers and become an Athens of the New South. The economy is booming; Vanderbilt University is virtually impossible to get into; Reese Witherspoon and Nicole Kidman both have homes here. The prosperity grows out of a live-and-let-live spirit, sometimes called the Nashville Code, where celebrities stand in line unaccosted at Starbucks in Green Hills and hipsters pour into formerly marginal neighborhoods to create little Brooklyns with a drawl.

OPPOSITE: Archer meets John Lewis. When asked about the role Nashville played in his development as a civil rights leader, the congressman replied, "Nashville prepared me."

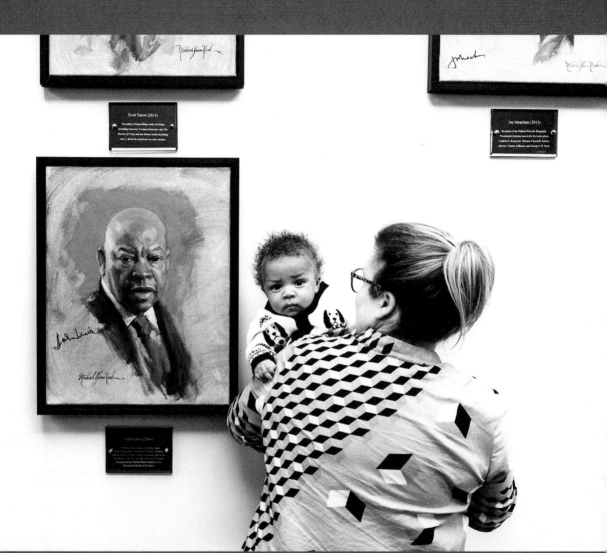

At once cosmopolitan and comfortable, Nashville can, depending on what you're looking for, be slick or sleepy, invigorating or calming. My wife and I, both Southerners by birth and inclination, moved our family to Nashville from New York six years ago. We loved Manhattan, where we had lived for more than a decade and where our three children were born, but as the kids grew toward their teenage years we became restless in the North. Though the world of doormen and taxis has its charms, the need to treat even a quick walk to Central Park as a mission akin to the invasion of Normandy—imagine strollers in the place of landing craft—was tiresome. We had kept a house in Sewanee, Tennessee, the tiny Episcopal college town where I went to school. We spent our summers there, and each year it grew progressively more difficult to pack up for the re-migration to New York. On something of a lark, after our fifteenth summer, we made an appointment to look at houses in Nashville.

The city was not totally foreign territory. I had grown up in Chattanooga; my wife, in Mississippi; and I had spent many pleasurable hours here while working on a biography of Andrew Jackson, so we thought it worth the exploratory trip. We fell in love with the first house we saw—an old neo-Georgian with lots of space—and, through friends, intuited what we now know to be true: the city offers the best of familiar Southern life with more engaging cultural offerings than any one person can truly experience. In a word, it seemed perfect. And so it has proven to be.

Art—visual, sung, written—is the city's soul. Nashville was home to the Fugitive poets in the early twentieth century, a band of writers that included Robert Penn Warren, Allen Tate, and John Crowe Ransom. The Frist Center for the Visual Arts sits in the middle of town, hosting first-class exhibitions such as *Secrets of Buddhist Art: Tibet, Japan, and Korea* and a retrospective on Irving Penn. In music, this is still a place where talented dreamers arrive unknown with hopes of immortality. Tim McGraw showed up one day in May 1989. He'd sold everything he had back home in Louisiana, boarded a Greyhound bus, and arrived in town with his guitar. It's a legendary tale that happens to be true. He played at Skull's Rainbow Room in Printers Alley in downtown Nashville and slept on a friend's couch before he got his first record deal.

What's culturally striking is how the city's different tribes manage to create a unified sensibility rather than a divided one. There are, among other elements, the old-line families in West Nashville,

the music world presided over by McGraw and Faith Hill, Cassidy and Dierks Bentley, and Jack White, and the book universe centered on Ann Patchett and Karen Hayes's independent bookstore, Parnassus. The photographer Jack Spencer is based here, living and working in a converted warehouse on the train tracks; the distinguished author and songwriter Alice Randall is Vanderbilt's writer-in-residence and the faculty head of a freshman dorm on the university's beautiful Ingram Commons. Taylor Swift has a place in town, and Witherspoon has opened a store in 12 South.

Growth, of course, brings growing pains. The prosperity in some quarters has cast a needed light on those families and neighborhoods left behind. Public schools require more attention and resources; public transit has, to put it charitably, not kept up with the demands of a rising population. The problems are real, but they are the kinds of challenges a city wants to have if there must be challenges—and there always must be.

Last autumn, during the party for John Lewis's visit to Nashville, he and I talked a little bit about an interview we had done for *Garden & Gun* magazine. He had been kind to give me the time for it, I said; I knew how busy he was. Gracious as ever, he demurred and then turned to greet more well-wishers under the tent in Belle Meade. As I watched him, I remembered something he had said in that interview—something about the South and redemption. Later that evening, I looked it up. "I always felt growing up that in the South there was evil but also good—so much good," Lewis had said. "We are still in the process of becoming. I am very, very hopeful about the American South—I believe that we will lead America to what Dr. King called 'the beloved community.' I travel all the time, but when I come back to the South, I see such progress. In a real sense, a great deal of the South has been redeemed." Nashville now feels like a vital part of that larger story—a place where old and new meet, and move forward, together.

—Jon Meacham

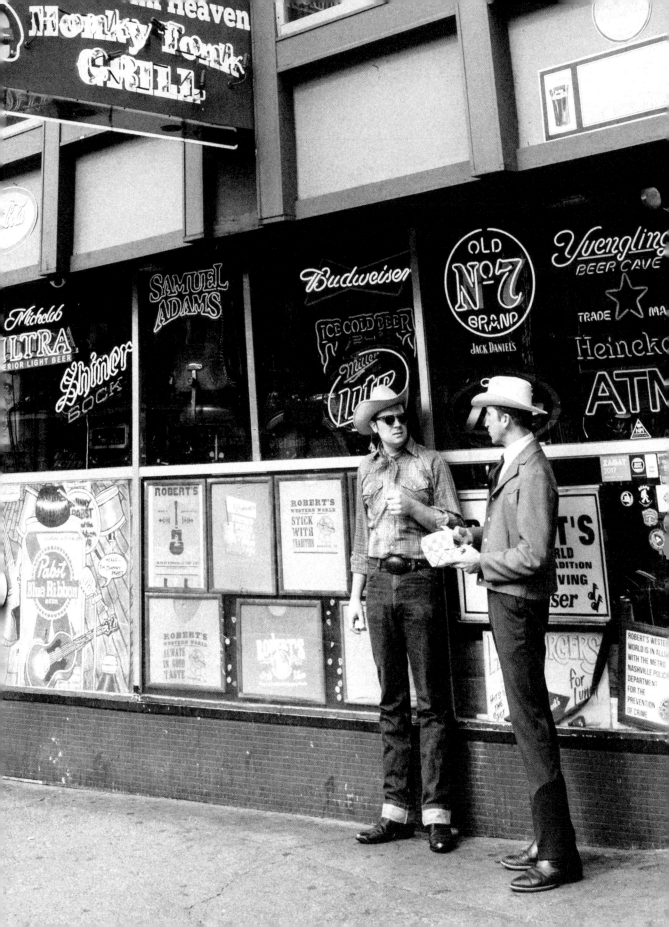

THE FERRY TAKES US BACK
AND THE WINGS BRING US HOME

There is a small road in Nashville, not too far off Charlotte Pike, that runs into the Cumberland River, and another road on the other side of the river that rises out of the water for no reason at all. When I was growing up, Cleeces Ferry ran between the two. The ferry held maybe a half-dozen cars. This was before they'd built the Briley Parkway Bridge, and so the ferry was the only way across unless you wanted to drive to Ashland City. There were always a few cars waiting on either side. The river isn't very wide and the whole trip took fifteen minutes, including the loading and unloading of cars. My sister and I stayed in the car and read our books. We didn't even look out at the water. As children, we failed to imagine a time when the ferry would be obsolete, or a later time when the ferry would be forgotten, when people might wonder why some idiot built a road that ran straight into the river.

I swore I wouldn't do this. I wouldn't write about what Nashville was. I would write about what Nashville *is*. After all, what Nashville is and what it was bear pretty much no relationship to each other. Or they do bear a relationship, just not a resemblance. Even the river has changed.

OPPOSITE: A smoke break on Lower Broadway.

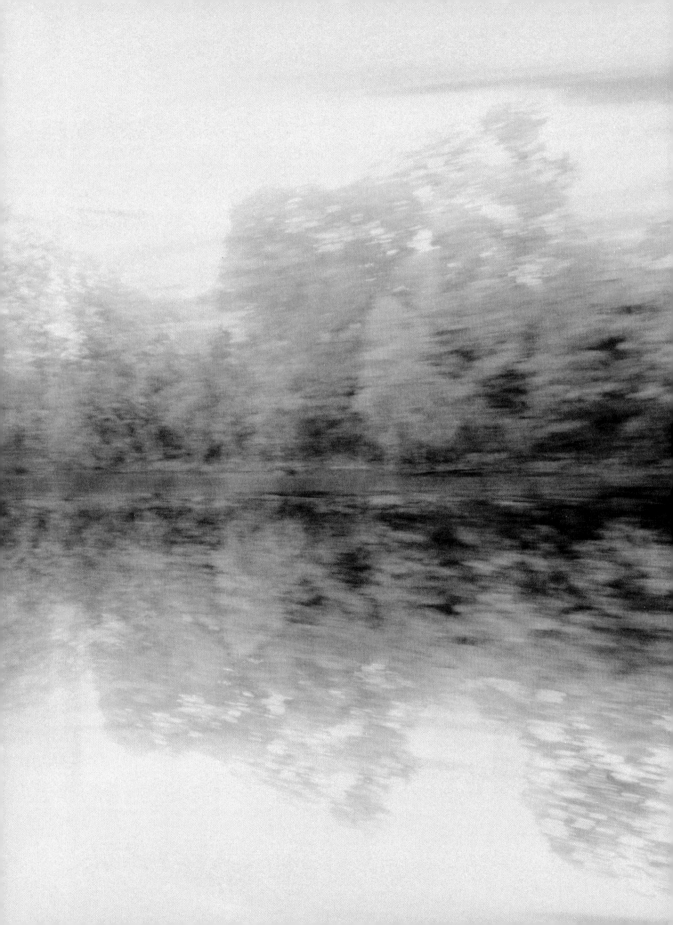

When I was growing up, Acme Farm Supply downtown, which everybody called Acme Feed and Seed, was the place we went to buy molasses oats for the horses. It was where we bought pig feed and those little pellets the rabbit liked. The place smelled like a tack room, like dust and hay, with a floor of wide, unvarnished boards. That same building now houses a restaurant and bar called Acme Feed and Seed. The red-and-white checks that were meant to call Purina to mind are still painted on the second floor, but there is no feed corn or seed corn or dog food. Instead there is an attractive hostess who tells us our table is right this way. The first item on the menu is chicken *tinga*, and I wish I could go back in time to tell the men in overalls who loaded the fifty-pound bags of chicken chow into our station wagon that one day this place would be a restaurant called Acme Feed and Seed, and if they wanted a plate of chicken *tinga*, they would need to call at least a week in advance for a reservation.

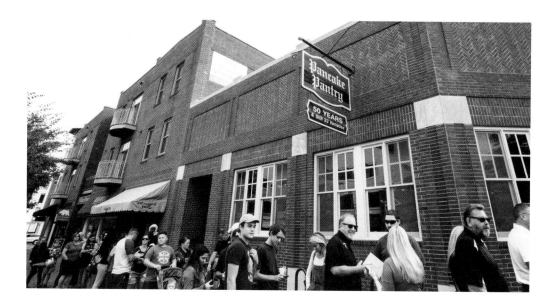

PAGES 14–15: Cumberland River.

∾

ABOVE: The Pancake Pantry has had a line down the street since it opened in 1961. When the crowds became too overwhelming, they rebuilt the same restaurant next door, doubling the size.

I can play this game forever: the coffee bar Fido in Hillsboro Village has a neon sign in front that says "Jones Pet Shop." That is not some random bit of kitsch; that storefront actually *was* Jones Pet Shop, the place my sister and I walked to every day after school to admire the puppies. I can order a latte and remember the cockatiel who would whistle at us and say "pretty bird" whenever we walked past the cage. We went to St. Bernard Academy down the street, a convent school where the nuns lived on the top three floors, but now the nuns are gone and their tiny bedrooms have been repurposed as artists' studios and offices for therapists, nonprofits, and aestheticians who wax.

This is how the past works—the new thing sits in the place where the old thing was, except that in Nashville the changes come faster and are more sweeping, more devouring, than anything I've ever seen. Or as Heidi Ross, who took the photographs in this book, explains, "It's like someone came in during the night and dropped an entirely new city on top of the city where we live."

If I gave you the statistics—the number of new residents, the number of cranes looming over building sites, the number of new restaurants and new jobs—they would be out of date before you finished reading. Simply put, the city is growing like a weed, which means that every field of weeds I remember is now underneath a condominium complex.

But aren't people like that too? When you look at anyone you've known for a long time, aren't you seeing both the person they are now and the traces of all the people they used to be? Don't parents know that somewhere deep inside the sulky teenager slamming his bedroom door is the baby whose toes they counted and kissed, the toddler racing into their arms, the six-year-old crawling into bed beside them? Why should a city be any different?

Sure, I remember Nashville before there was traffic, I remember when cows grazed alongside Abbott Martin Road, but I also remember leaving Nashville in 1981 to go to college in New York and being floored by the escalators in Bloomingdale's—wide enough for two people, or even three, to stand next to one another comfortably! The escalators in the Cain-Sloan and Castner Knott department stores were barely as wide as my hips, and they groaned and shook as if the stairs were pushed upward by the labor of unseen men turning cranks. You know you're still a country girl when you come home from New York City raving about how nice the escalators are.

At Service Merchandise downtown, not far from Acme Farm Supply, the clerk put your money and the bill of sale in a pneumatic tube that was then sucked away to the cashier's office upstairs where change was made. After the transaction was complete, the tube came flying back across the ceiling and down the wall and into the waiting hands of the clerk. So while I can see quite clearly that Nashville is the Golden Mecca of New Growth and Opportunity, I want to tell you that it hasn't been true for very long. Growth and Opportunity are built on the pneumatic tubes that run just beneath the surface of my memory.

It makes me wonder: Who sees Nashville exactly as it is now? Not a friend of mine who moved here two years ago, and talks every day about how much things have changed. I once met a couple who had lived here only four months, and even they said the city was nothing like the one they'd first come to. No matter how long we've been in Nashville, fifty years or fifty-two days, with all the dates in between, I have to think we're all living in some combination of the present and the past, layering the street corners with our personal memories of what has vanished.

Except, of course, for the tourists.

The tourists come in droves, those happy travelers, their cowboy boots pounding the streets seven days a week, every hour of the day and night. Tourists bathed in the neon light of bars, dancing in conga lines past the Goo Goo Shop. Tourists up at dawn, rushing off to church service or to get in line at the Pancake Pantry. They're out there in their cowboy hats on days it's too hot to think about being outside. They're out there in the rain under ponchos. They've come for business conventions and vacations. They've come for the first time and have already made plans to come back. They're here for the tenth time with their friends and families. They heard great things about Nashville, and the city has delivered.

Nashville has opened her arms to tourists for as long as people have been driving in from distant farms to see the Grand Ole Opry on Saturday night. They come for Fan Fair, the State Fair, the Titans game, the Predators, the Country Music Hall of Fame, the Americana Music Festival and the Tomato Art Festival, and the Brad Paisley concert. They come to see the Ryman Auditorium and Hatch Show Print and Third Man Records. They wander in and out of the honky-tonks on Lower Broadway. They come for bachelorette parties—eight or ten young women wearing matching "Team Bride"

T-shirts—with one young woman wearing a long flounce of netting pinned to her ponytail. The tourists, while vastly increasing in number over the years, have been a steady presence. I can remember when Nashville didn't have Japanese food, but I can't remember a time without tourists.

So maybe they're the ones who really see us as we are. For one thing, they're actually *looking*, heads thrown back, cameras pointed to the skyline. They stop to admire everything. They do not divide their affections, or point out which building has always been here and which one is new. They take the city as they find it, and accept what they are walking past. They see Nashville for all its beauty and its architectural inconsistencies, and they fall for it hard. Which is the difference between being seen by someone who's known you forever and being seen by a stranger. The person who's known you forever remembers your history and they love you for it and they hold it against you a little. The stranger just sees *you*, standing there at this exact minute, your past fully integrated into your present. Two strangers can have chemistry, and strike up a passion, and so can a city with a tourist who's fresh off the plane.

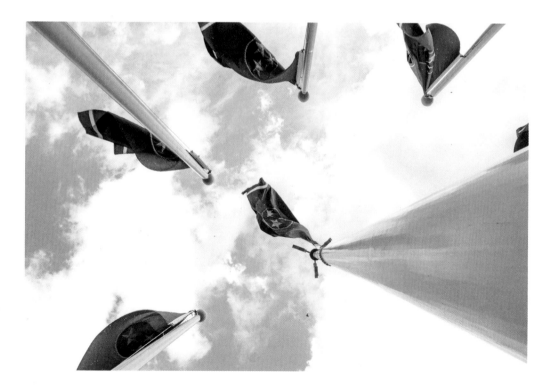

ABOVE: State flags in Bicentennial Capitol Mall State Park.

So while someone who has lived in Nashville for years will talk your ear off about how the Gulch is just a made-up place that used be the Station Inn and some sketchy parking lots, a tourist will marvel at this cool neighborhood called the Gulch. They will stand in front of the mural of the giant wings to have their picture taken. They will never wonder how long the wings have been there. They will not want to tell you what was on that wall before the wings arrived. They just dive in with their hearts open wide, and they love those crazy wings.

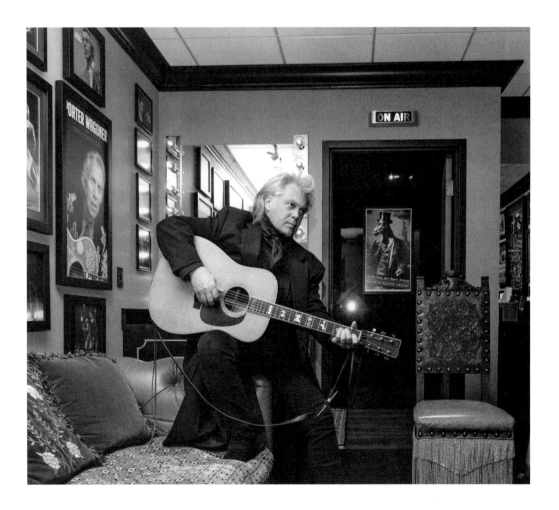

ABOVE: Born in Philadelphia, Mississippi, Marty Stuart started playing guitar with the Sullivan Family at the age of twelve. At fourteen, he joined Lester Flatt's band the Nashville Grass.

A chunk of Nashville's population will always consist of a group of people who are neither residents nor tourists. These are the people who are trying the city on for size. Nashville has always been a magnet for talent, for dreamers, for people with beautiful voices, for people who are uncannily proficient on at least three instruments and can clog, for people who know how to distill heartache and joy into a handful of rhyming couplets. If the Statue of Liberty says, "Give me your tired, your poor, your huddled masses yearning to breathe free," then Athena over in the Parthenon would be saying, "Send me your soulful artistic folk and I will hold them in the palm of my hand with Nike."

Talent has been saving up gas money to get to Nashville for time immemorial. Talent has flourished and thrived, waited tables, sung at The Bluebird, signed a record deal, and made history. Talent, real talent, has also busked on the sidewalks, met with exhausting rejection, finally pawned its guitar and spent its last dollars getting drunk in Tootsie's Orchid Lounge (or nowadays, Dino's). Some people make it and some people don't. It's both a cliché and a fact. The interesting part is that a lot of the people who came with big dreams—met or unmet—decided to stay in Nashville to have a life. They got in the habit of walking the trails in Percy Warner Park in the morning or doing the loop around Radnor Lake. They liked the hot chicken, the meat-and-three, the independent bookstore. They made note of the fact that people were friendly, unusually friendly, even though most of the people they met weren't even from here. It's as if everyone got the same memo: If you want to pass for a local, you have to be nice. If the door that leads directly to the stage of the Grand Ole Opry didn't swing open, the doors to people's houses did, and so they stayed. They became the pioneers of the hip new East Nashville, of Germantown and the Nations. By the sheer force of their numbers and the shimmer of their talent, they shaped the city into something they owned.

As emotions go, nostalgia is both cheap and unrealistic. We can't go back. That's not the way time works. We have a bad habit of forgetting everything progress provides while mooning over a much-loved oak tree that was bulldozed. Sometimes we're not even nostalgic for things we *liked*, it was just that we were used to seeing a particular thing in a particular place. (See: Colonial Bread Factory.) The new Nashville is modern, which is something that no one would have accused the city of being even five years ago. The music, always good, is now eclectic and wide-ranging, still the heart of country but also the heart of everything else. There are so many good new places to eat you can't decide

where to go. There are walkable neighborhoods and bike trails and community centers. There are legions of smart young people starting new businesses, creating new jobs, making art, making culture, and figuring out a way to make a difference. We've gone from sleepy to vibrant in an anthropological blink of an eye.

In the end, there's nothing that can be said about Nashville that is universally true, except that the city is changing. And there's nothing that can be said about Nashvillians that is all-encompassing, except that we are diverse. We are a people of many races with a long and fierce history of both oppression and liberation. We are the city where Congressman John Lewis sat at the lunch counter in Woolworth's, got knocked down, and stood up to make his country better. We are a city of countless ethnic backgrounds and a wide range of religious faiths. We stand tall on both sides of the American political divide. We are supporters of all things independent. We reinvent ourselves at least once a day.

That's why we hope this book can capture a moment of this beautiful city. We're not trying to immortalize it. Nashville has already been immortalized in film (*Nashville*) and television (*Nashville*) and in more songs than could be counted. We only mean to document the feeling of the place, to appreciate it and be grateful. And maybe someday, years from now, someone will pick this book up and say, "Where did those wings go? I remember when there were wings painted on the side of that building."

You can tell them the wings went the way of the ferry. They used to be here and then they flew off.

They will eventually. Everything does.

But while they're here, we should try them on for size.

—Ann Patchett

OPPOSITE: Kelsey Montague painted these twenty-foot-tall wings on the side of a building in the Gulch, and all day long people stand in front of them to have their pictures taken. It's called *What Lifts You*, and it does.

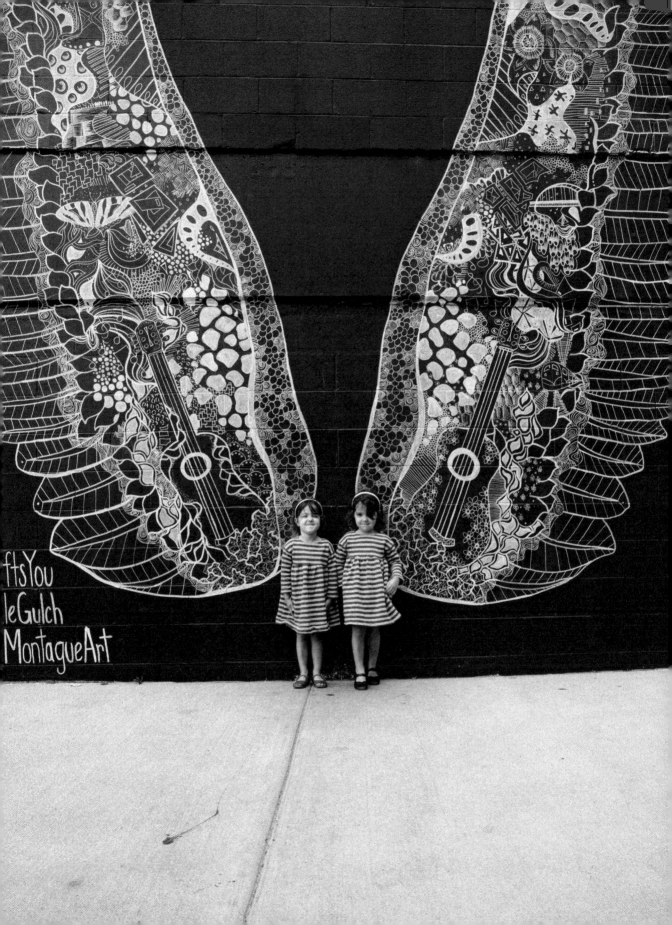

PLATES

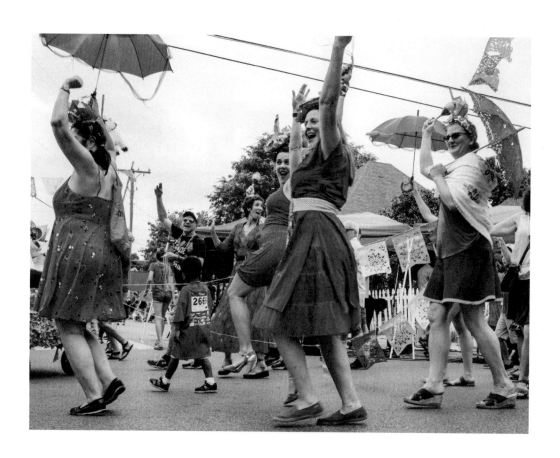

PAGES 26-27: Amanda Shires's wardrobe
case backstage at Ryman Auditorium.

~

ABOVE: East Nashville's Tomato Art Festival
is a celebration of all things tomato—"a fruit
and a vegetable: a uniter, not a divider."

~

OPPOSITE: Bolton's Spicy Chicken and Fish.

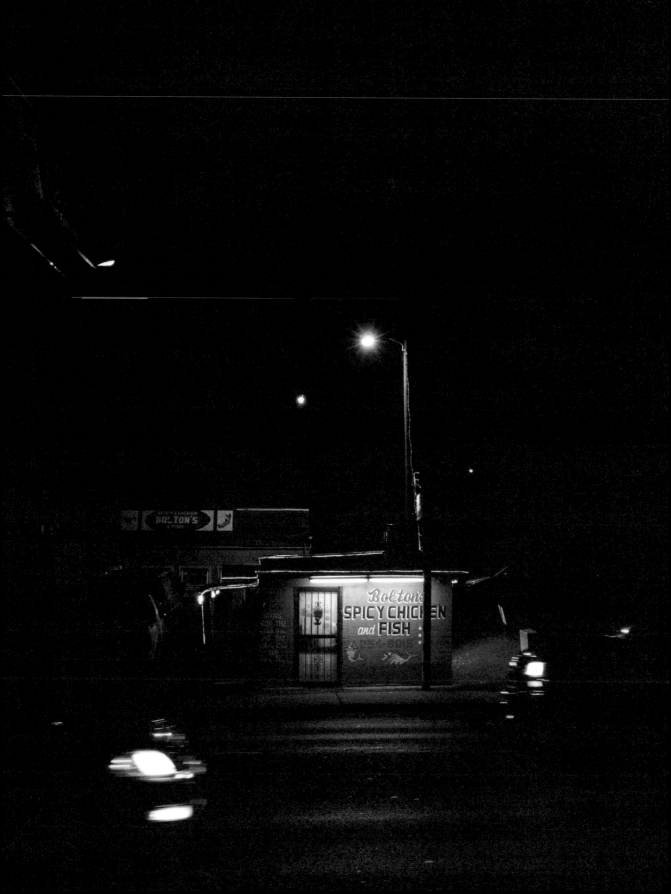

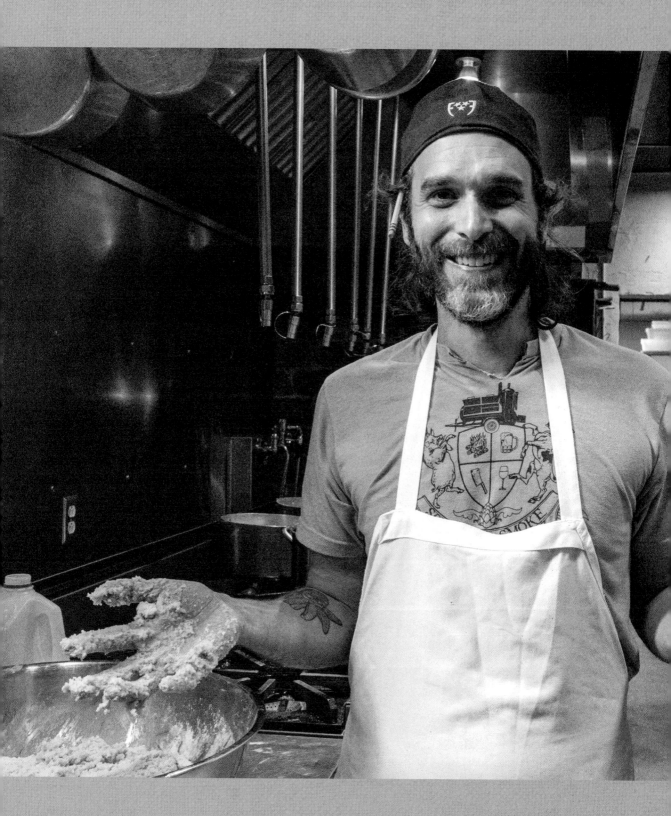

LEFT: City House chef and native son Tandy Wilson prepares to dredge local trout in cornmeal batter. His restaurant is Nashville's favorite place to see celebrities.

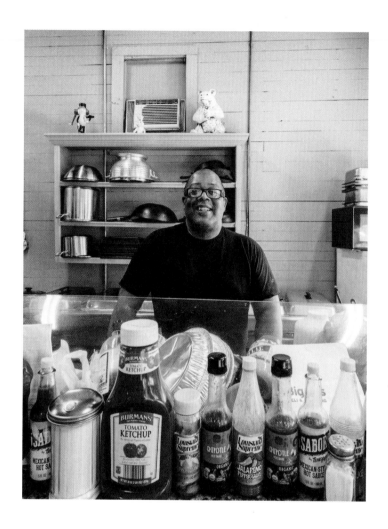

ABOVE: Alfonso "Big Al" Anderson opened
Big Al's Deli & Catering in Salemtown and
the place immediately became a classic spot for
Southern cooking for breakfast and lunch. Its
motto is "Food so good you'll slap yo mamma!"

❧

OPPOSITE: Al Gore backstage at War Memorial
Auditorium. It was in this room that he received
the results of the presidential election in 2000.

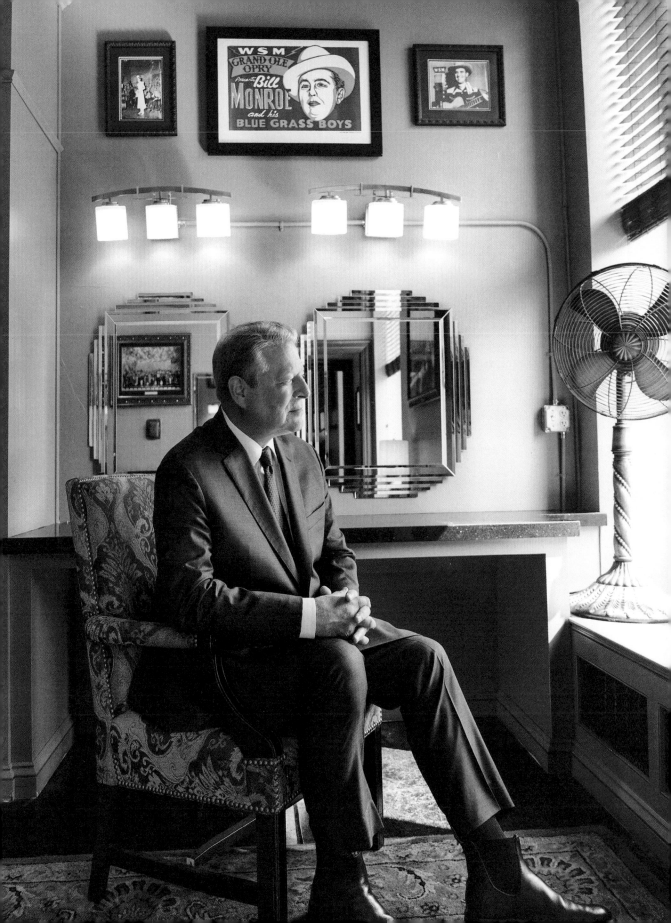

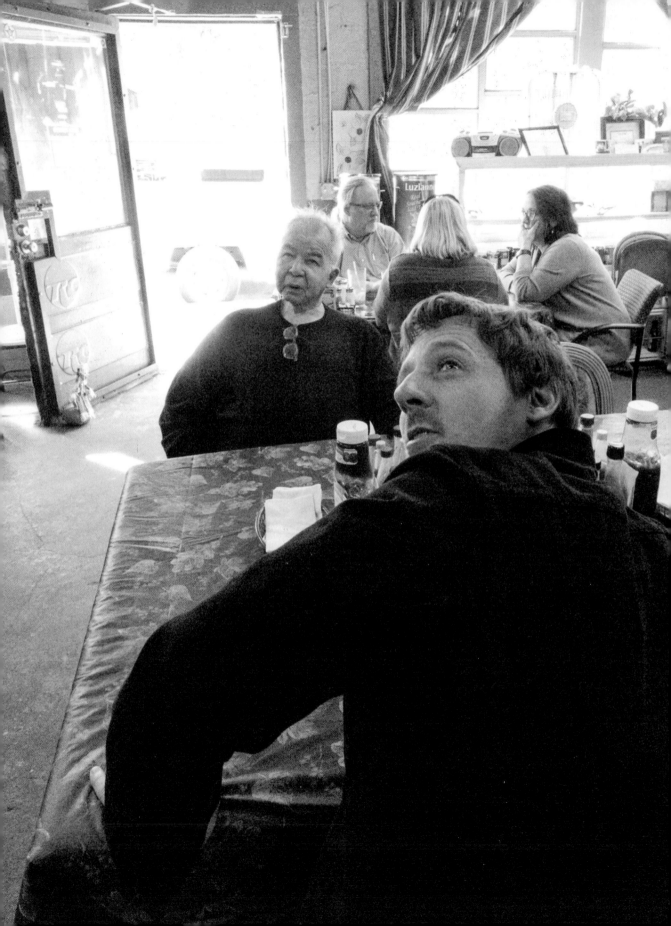

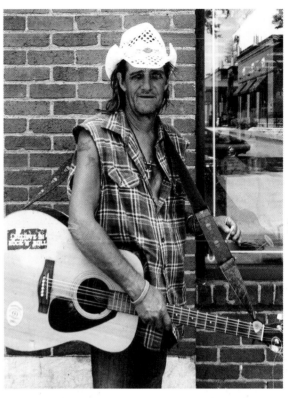

LEFT: Singer-songwriters John Prine and Sturgill Simpson (foreground) have a regular lunch date at Big Al's Deli in Salemtown.

~

ABOVE: Lower Broadway can be a boulevard of broken dreams or a lifetime gig for anyone with a guitar and a song to sing.

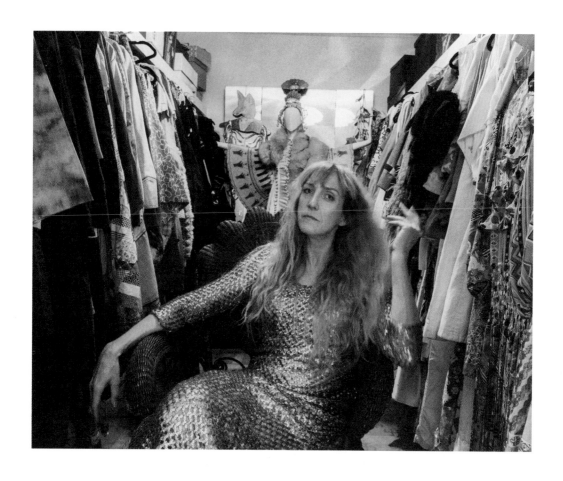

∾

ABOVE: Vintage queen Libby
Callaway was one of the
founding members of the
Nashville Fashion Alliance.
This is her closet.

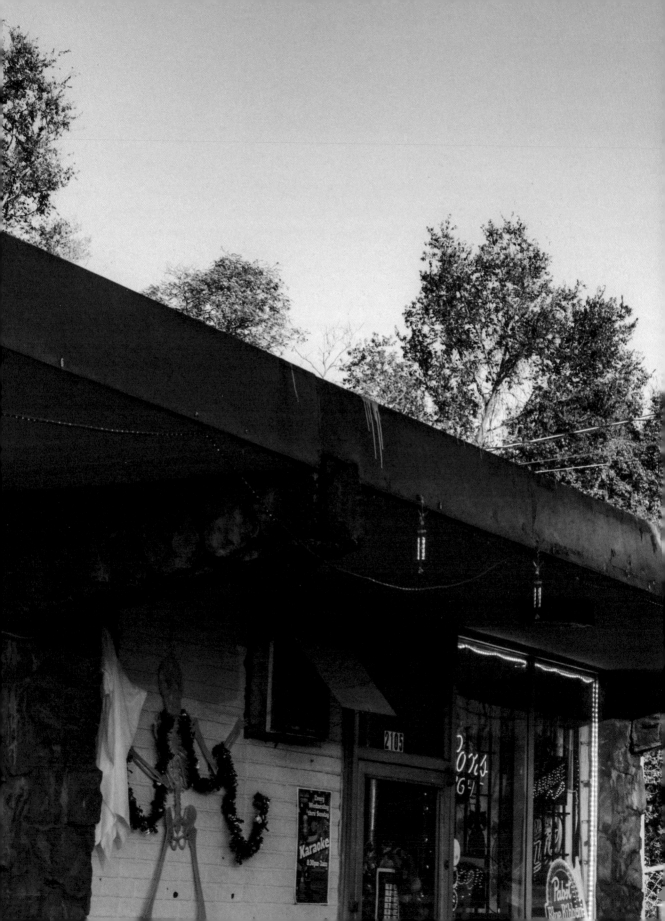

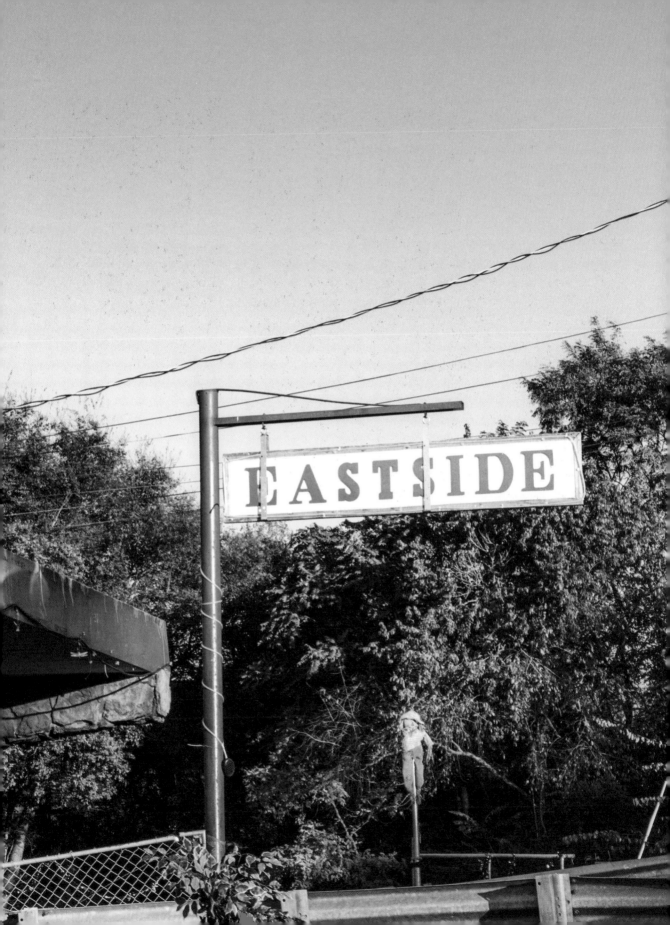

PAGES 38-39: If you come to Nashville and feel like singing (as many people do), go to Fran's East Side. This karaoke bar is open until midnight on Monday and Tuesday, and until 3:00 A.M. every other day of the week.

～

ABOVE: Nashville Zoo in the morning.

～

RIGHT: Elle Macho at The Basement.

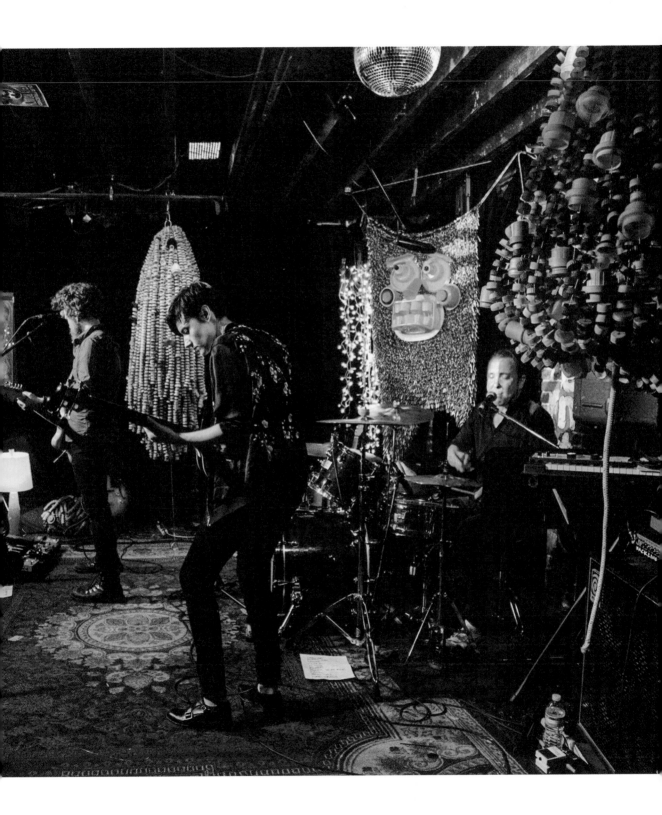

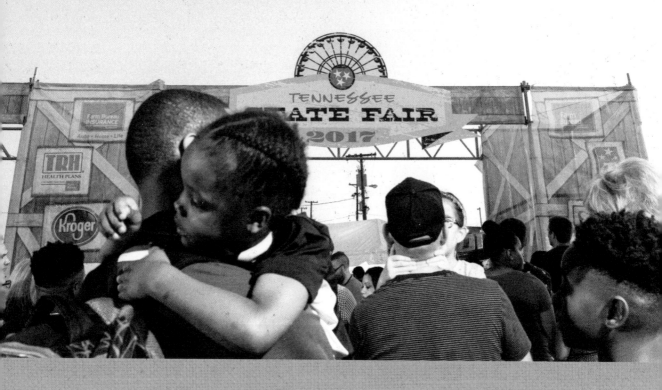

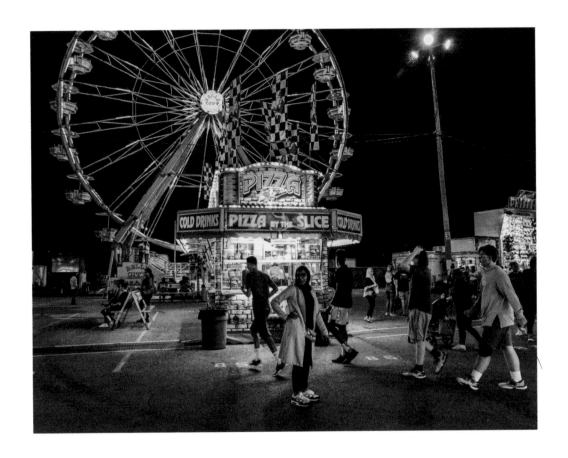

OPPOSITE: The Tennessee State Fair has come to Nashville every fall for more than 150 years. It has hosted Bob Hope, Sonny and Cher, and Sergeant Alvin York's prize Hereford.

~

ABOVE: Meet me at the Ferris wheel.

OPPOSITE: The next tattoo.

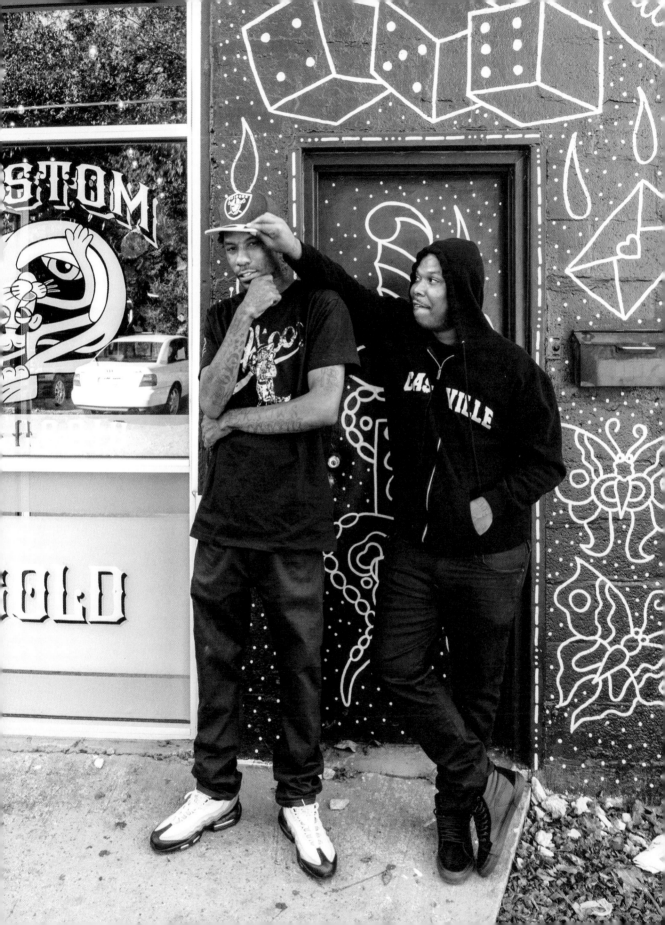

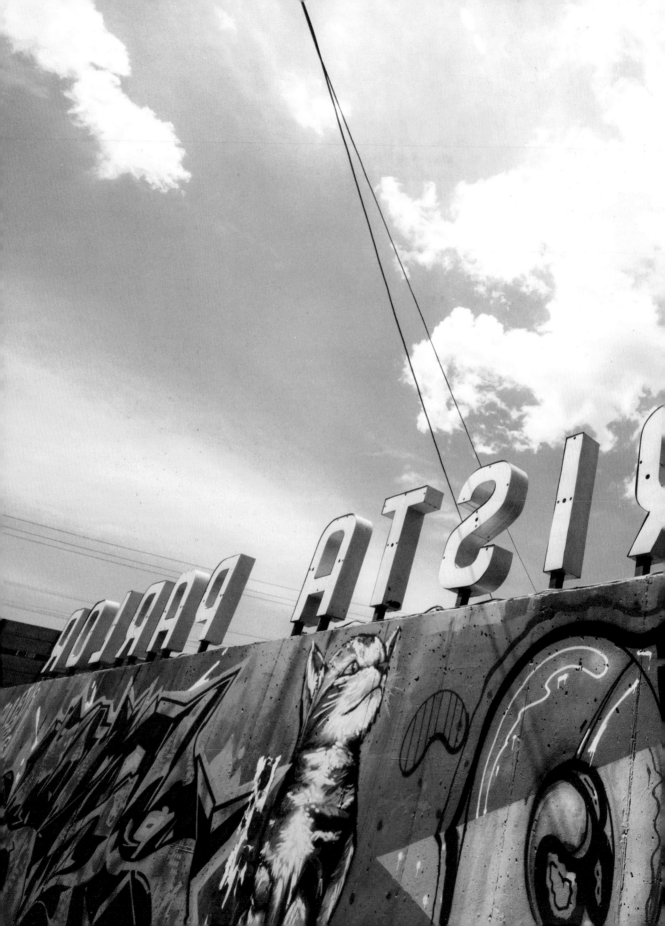

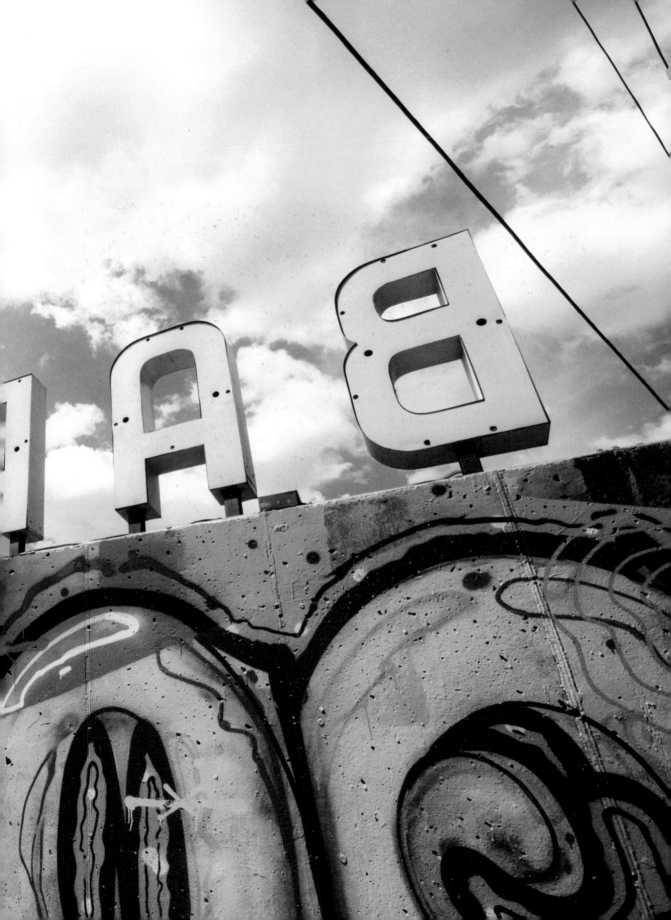

PAGES 46-47: Barista Parlor is the independent leader for intense East Nashville coffee.

～

ABOVE: The Predators made it to the Stanley Cup Final in 2017. Fans throw dead catfish on the ice as a testament to their loyalty and affection for the team.

～

OPPOSITE: It took a group of Tibetan monks five days to create a sand mandala in the Frist Center for the Visual Arts, to honor the bodhisattva of compassion. Three months later they returned and swept it away.

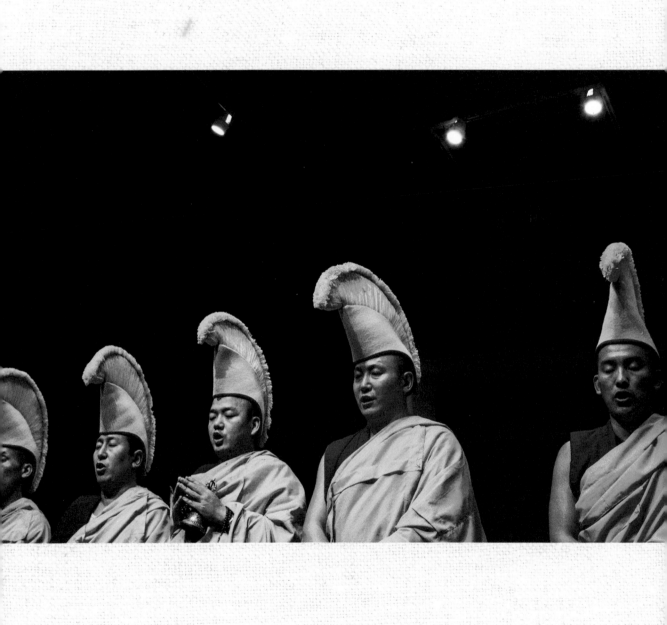

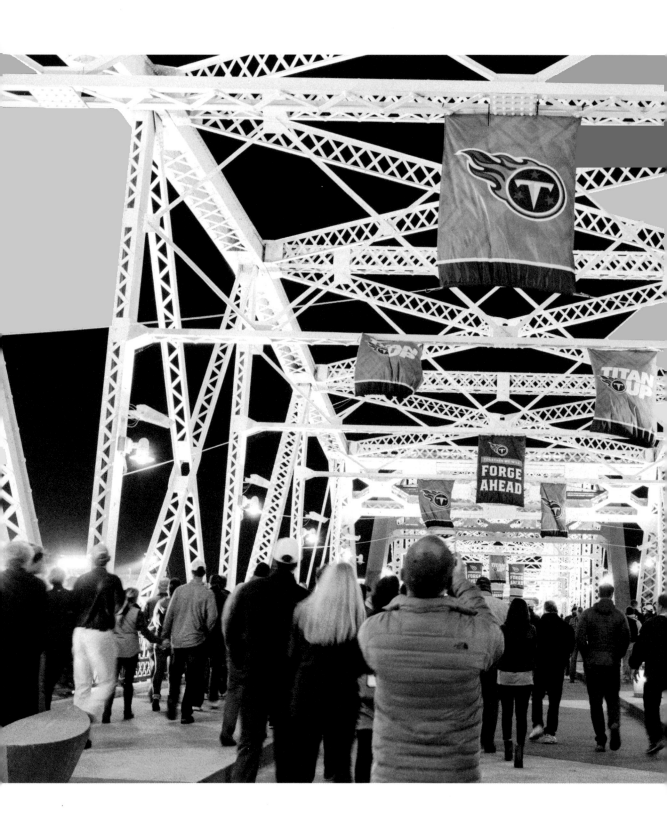

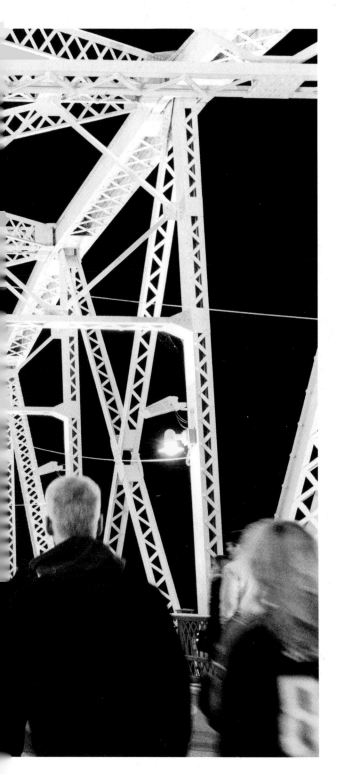

LEFT: Nashville has been known as the Athens of the South ever since the Parthenon was built here in 1897. Having a football team called the Titans just reinforces our claim.

∼

ABOVE: The view of Nissan Stadium, home of the Titans, from the John Seigenthaler Pedestrian Bridge.

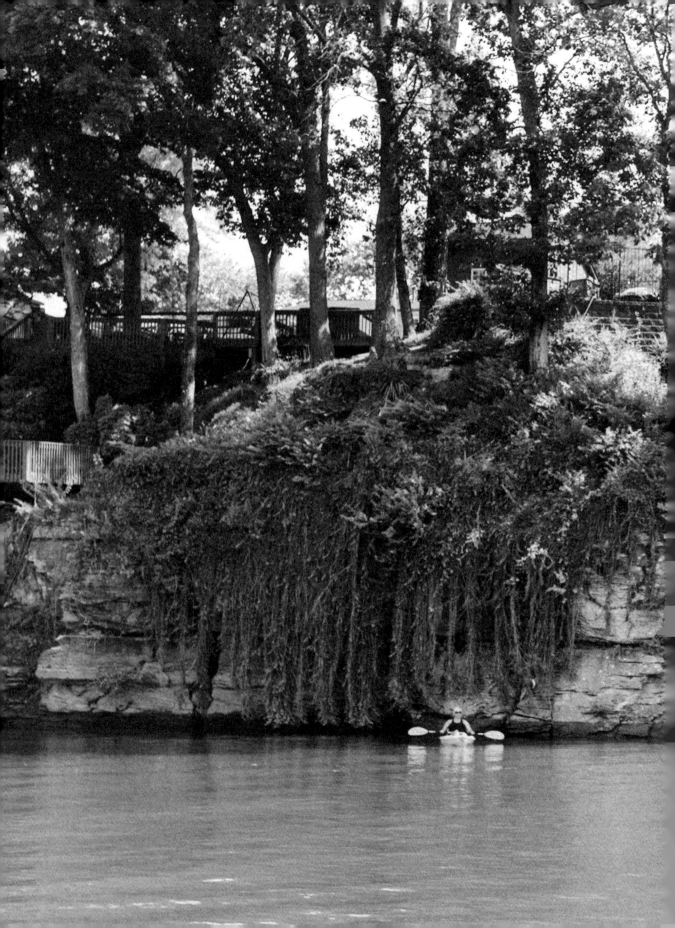

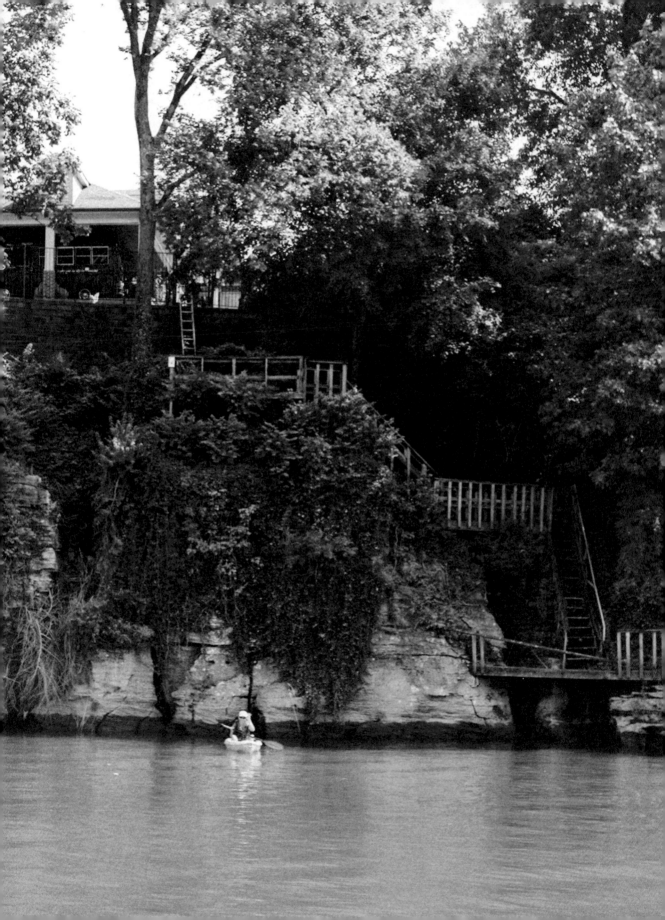

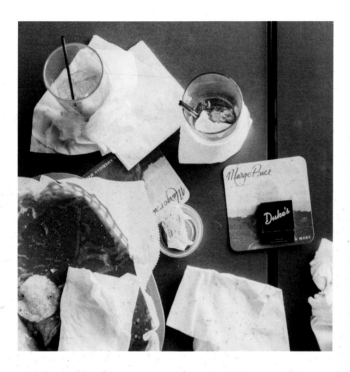

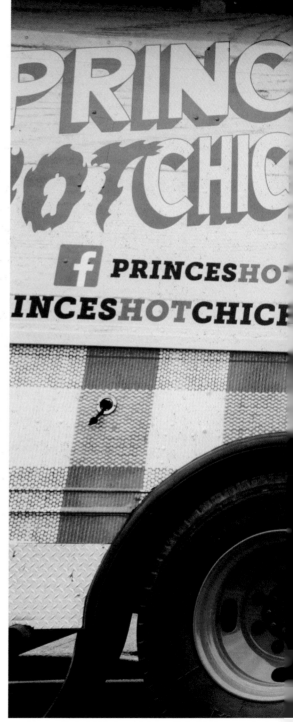

PAGES 52-53: Kayakers in the Cumberland River.

∾

ABOVE: Duke's promoted singer-songwriter Margo Price on coasters for the release of her second album.

∾

RIGHT: Nashville's classic Prince's Hot Chicken takes to the streets in a food truck.

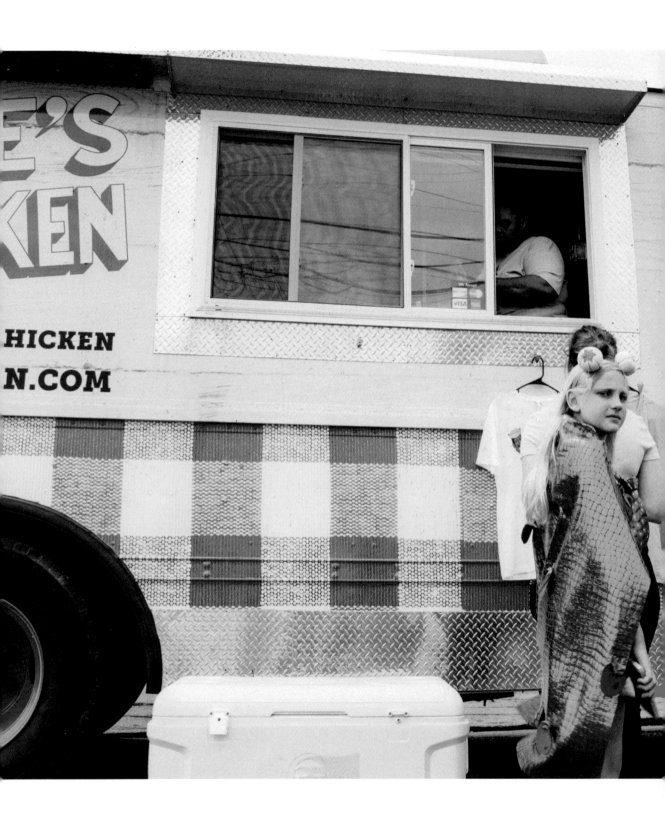

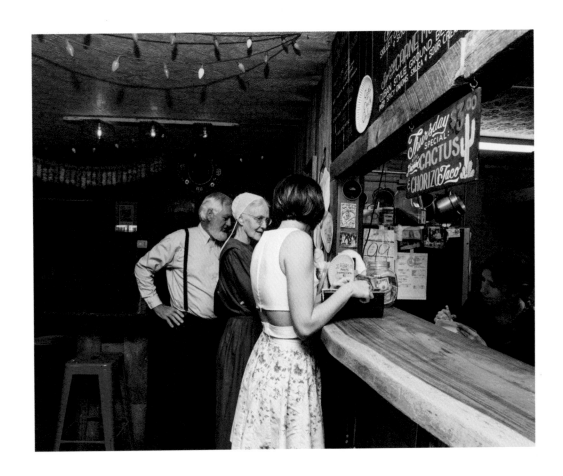

ABOVE: When worlds collide in Nashville, they tend to do so respectfully. This is the scene at Mas Tacos.

OPPOSITE: Make cornbread, not war.

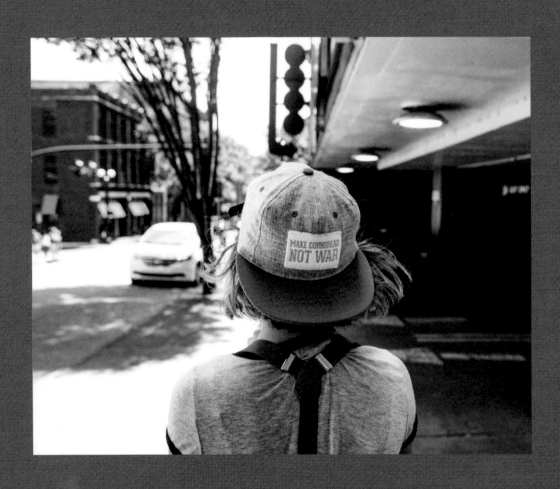

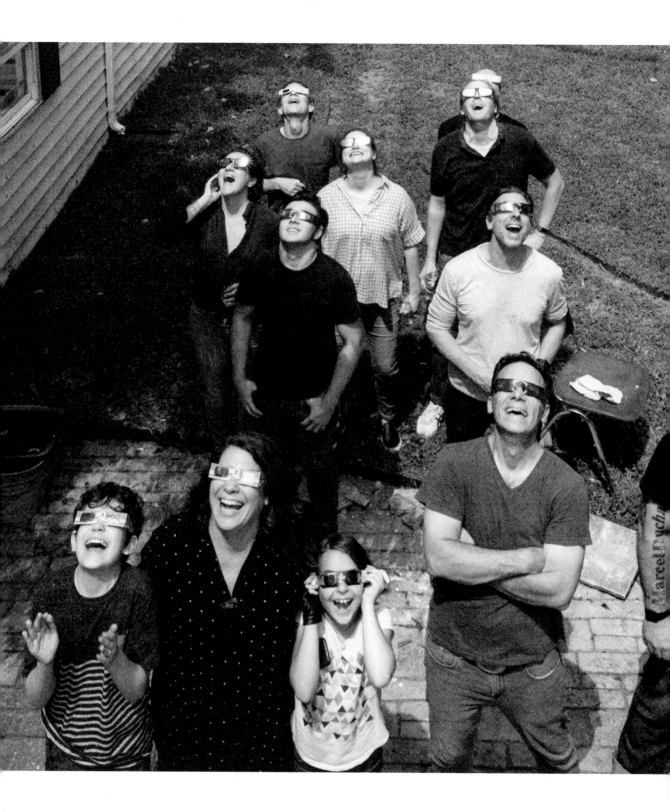

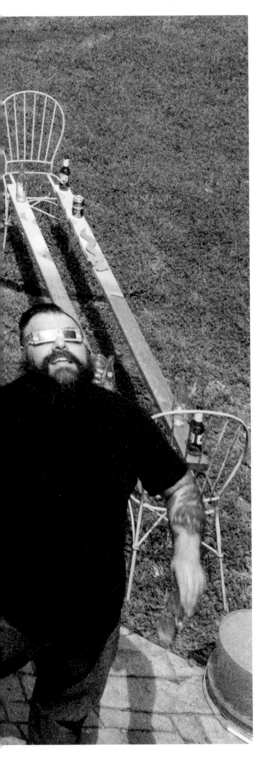

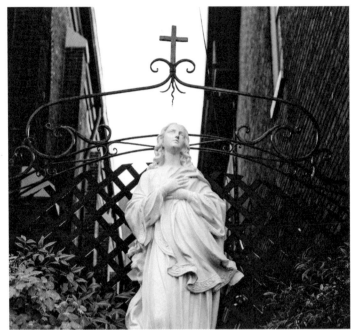

PAGES 58-59: Parnassus Books, an independent bookstore for independent people.

∼

LEFT: Nashville was in the path of totality for the 2017 solar eclipse. By some estimations, the city had as many as two million visitors. This group assembled in Cleveland Park.

∼

ABOVE: Mother Mary, Germantown.

JOHNNY
CASH
MUSEUM

DOWNTOWN

02-8876

OUTFRO

EXIT 209
otte
e

LY

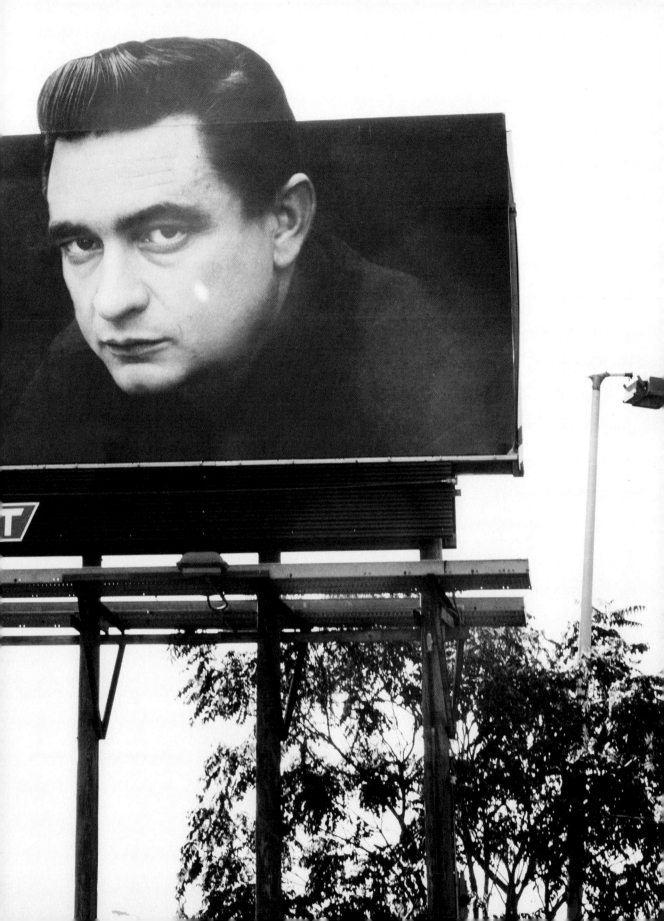

Johnny Cash: Nashville's T. J. Eckleburg.

~

The recording studio at the Johnny Cash
estate. Karl Silbersdorf and Dick Toops wrote the murder
ballad "Delia's Gone" in 1962. Cash recorded it in 1994.

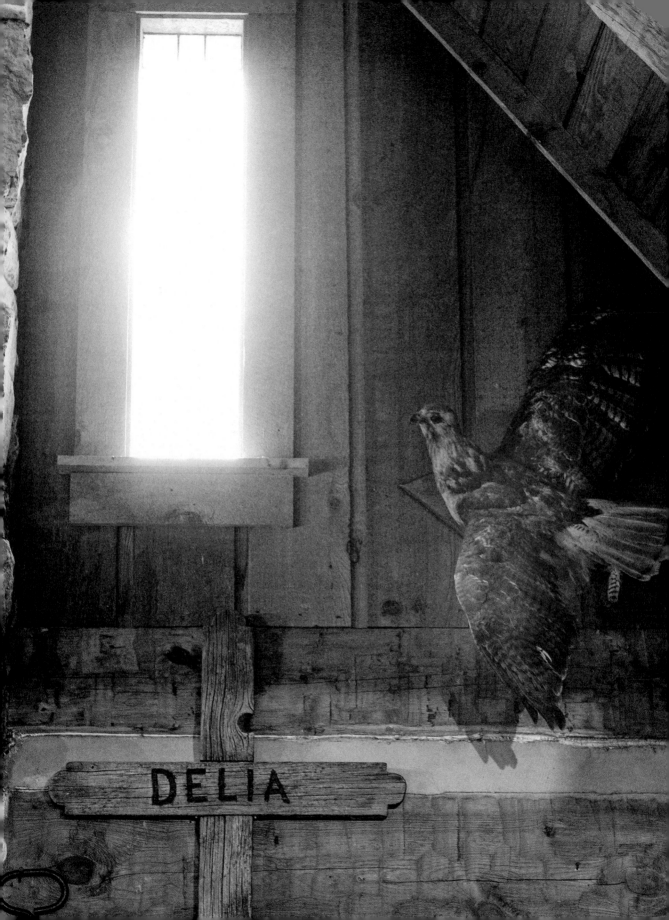

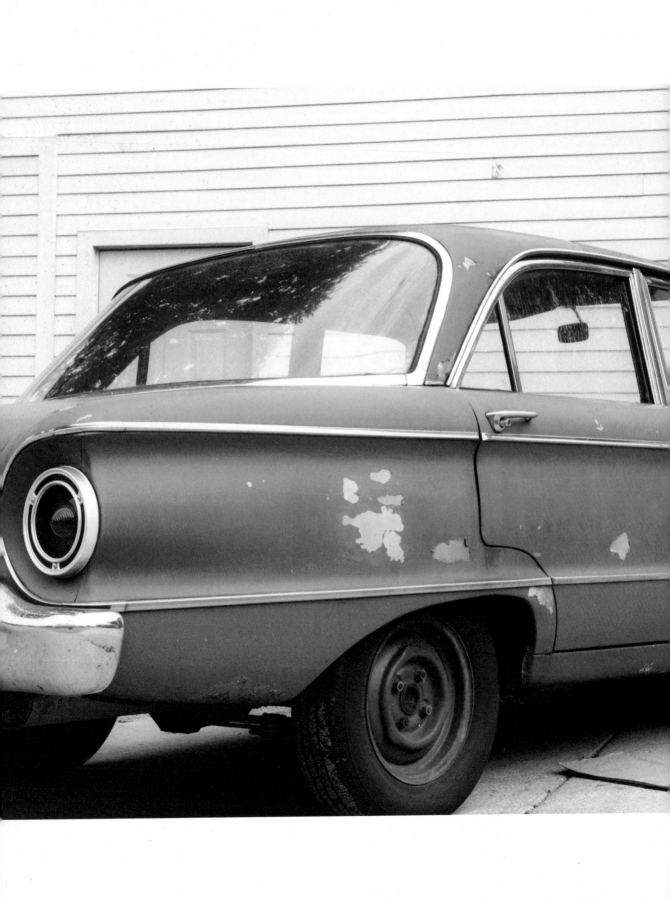

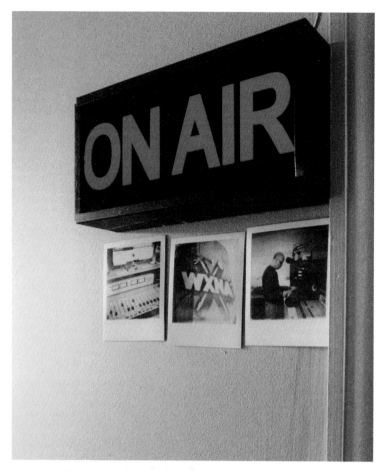

LEFT: On wheels.

~

ABOVE: WXNA is free-form radio, which means they play whatever Nashville needs to hear, from George Jones to the Ramones.

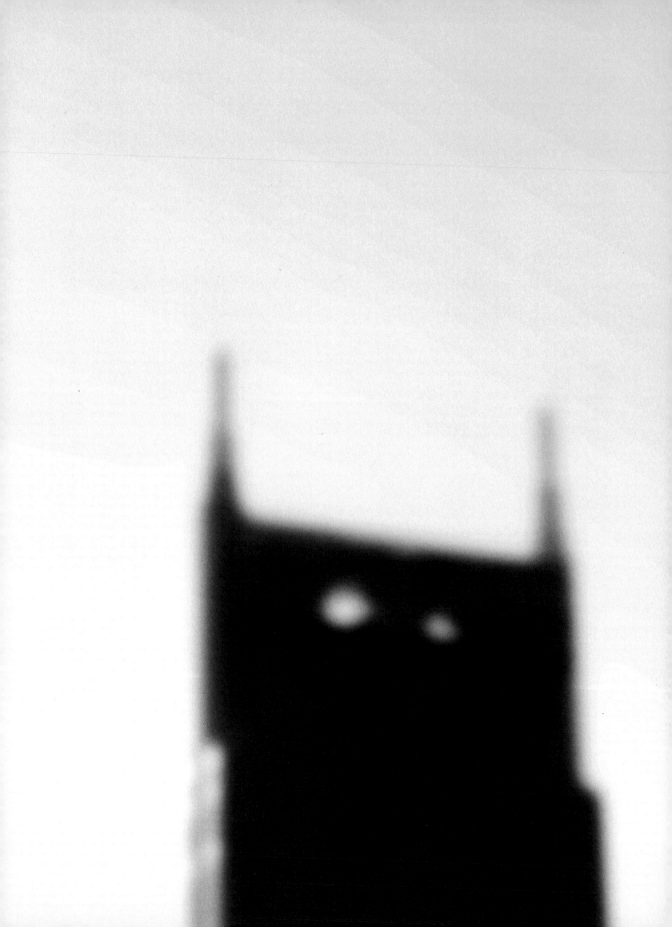

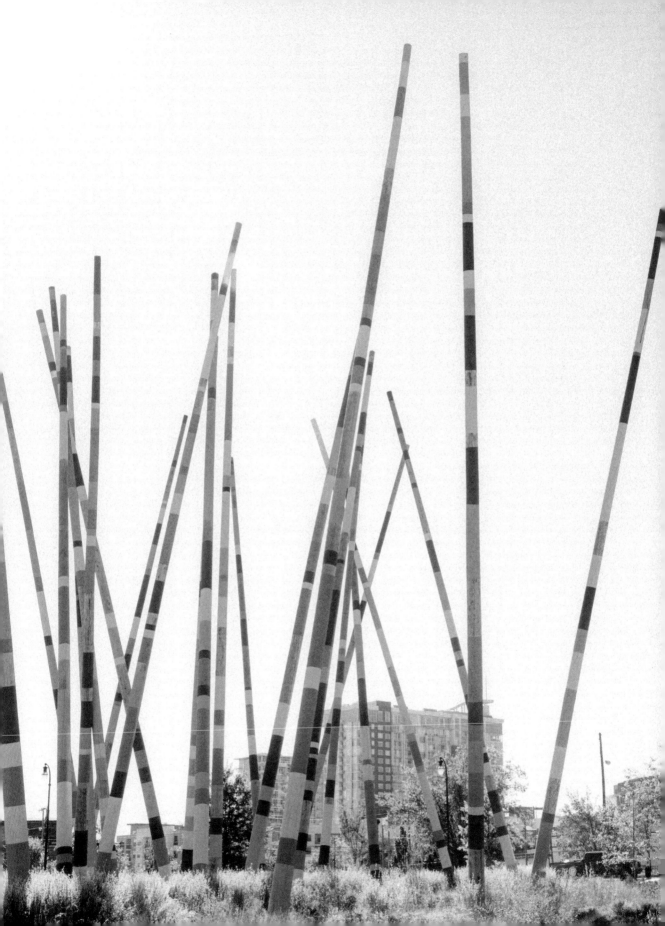

PAGE 68: No one will ever refer to this as the AT&T building, because it's not. It is the Batman Building.

~

PAGE 69: Christian Moeller of Frankfurt, Germany, created *Stix* for the Korean Veterans Boulevard roundabout, arranging twenty-seven red cedar poles to make Nashville's largest piece of public art. The poles are seventy feet high and had to be sunk fifteen feet into Tennessee limestone to keep them standing.

~

RIGHT: Riding shotgun.

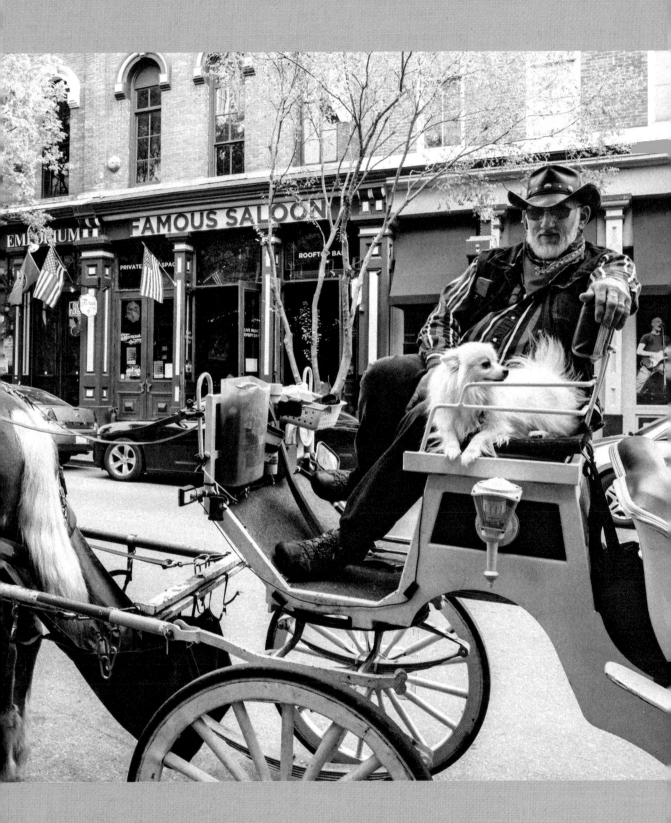

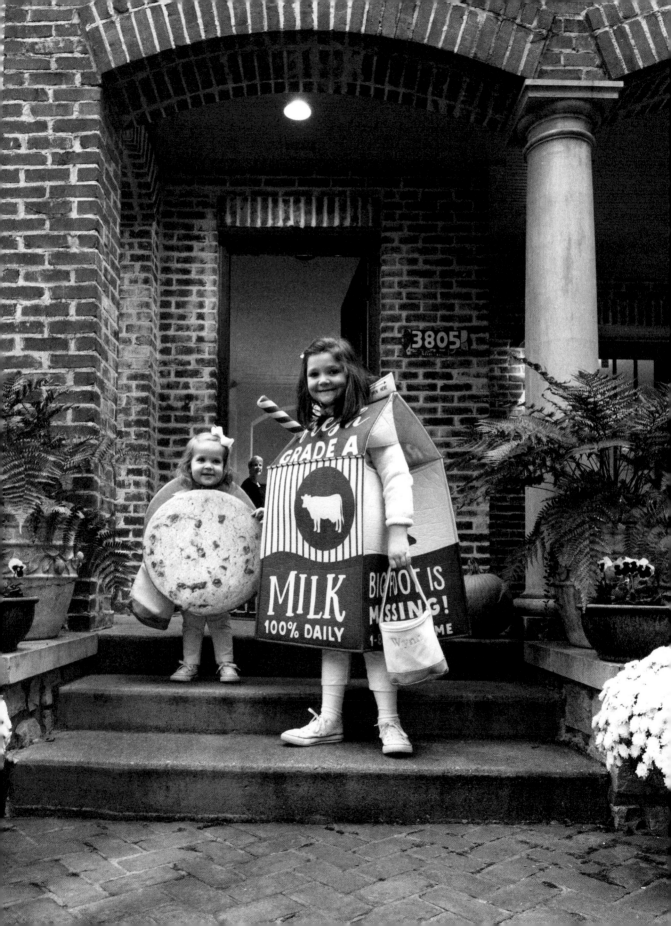

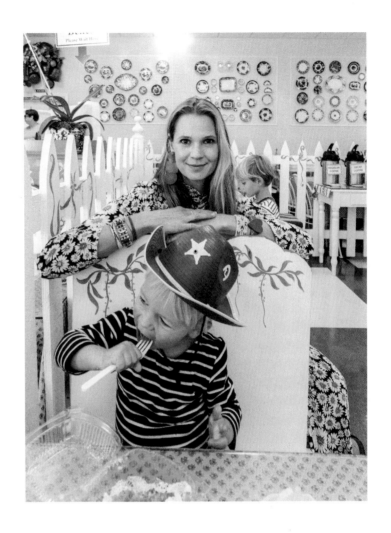

OPPOSITE: Milk and cookies.

~

ABOVE: Artist Vadis Turner and sons at the Picnic Cafe. If you wonder where Nashville locals eat and the tourists never go, it's the Picnic.

LEFT: Artist and textile designer Andra Eggleston with her son, Louis.

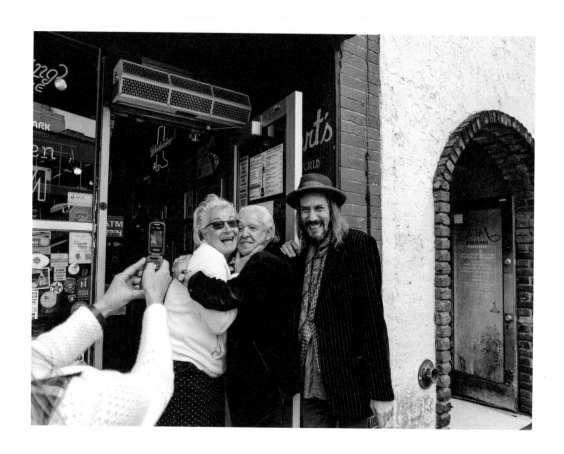

ABOVE: Manuel Cuevas's custom suits created the
iconic looks of the biggest stars in country music
by using embroidery, rhinestones, and fringe. He is
still mobbed by fans. He still loves it.

⌣

OPPOSITE: Bespoke designers Savannah Yarborough of
Atelier Savas and Manuel Cuevas of Manuel Couture.

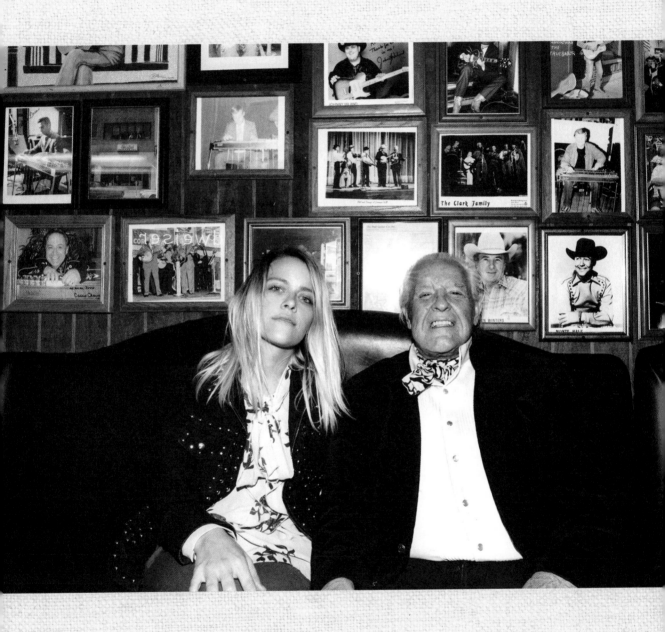

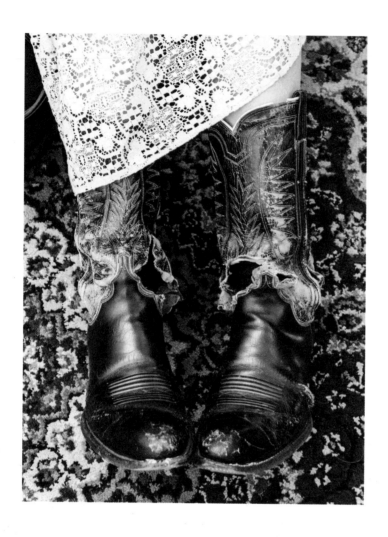

ABOVE: Gillian Welch and her prized ostrich-skin boots.

~

OPPOSITE: David Rawlings has put his mark on Nashville's music scene as a singer, songwriter, guitarist, and producer. He was trained at Boston's Berklee College of Music. We don't hold it against him.

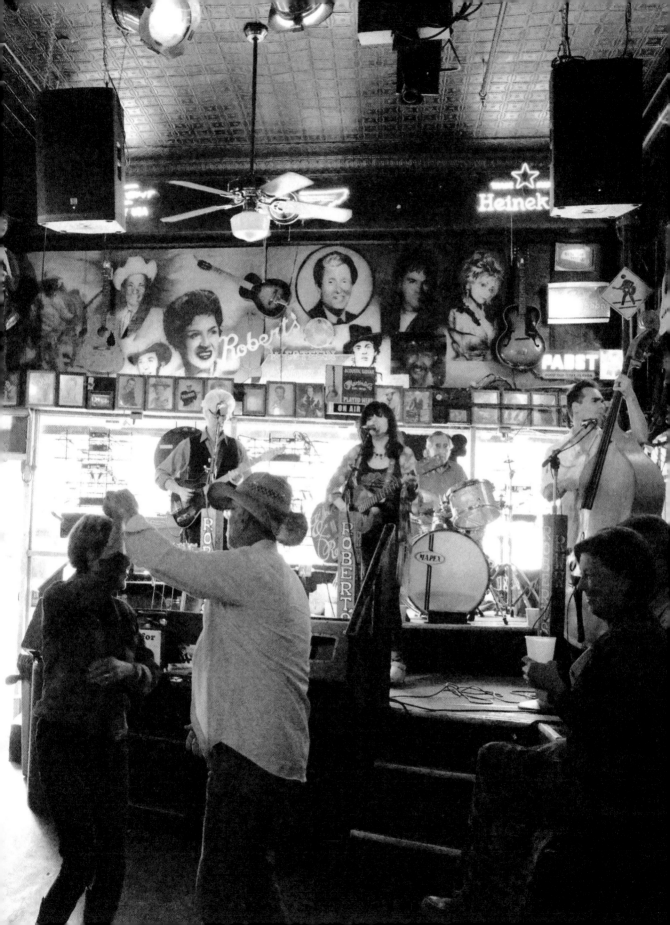

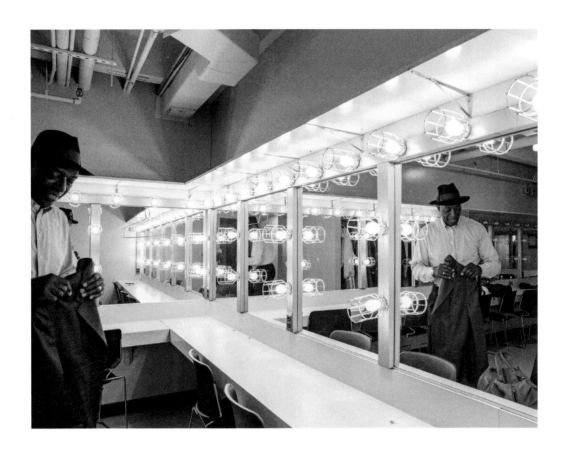

OPPOSITE: Robert's Western World honky-tonk on Lower Broadway, at two o'clock in the afternoon on a very average Tuesday.

∾

ABOVE: Donald Holmes backstage at the Tennessee Performing Arts Center. He's on the board of directors for the Nashville Opera. He is also an occasional supernumerary.

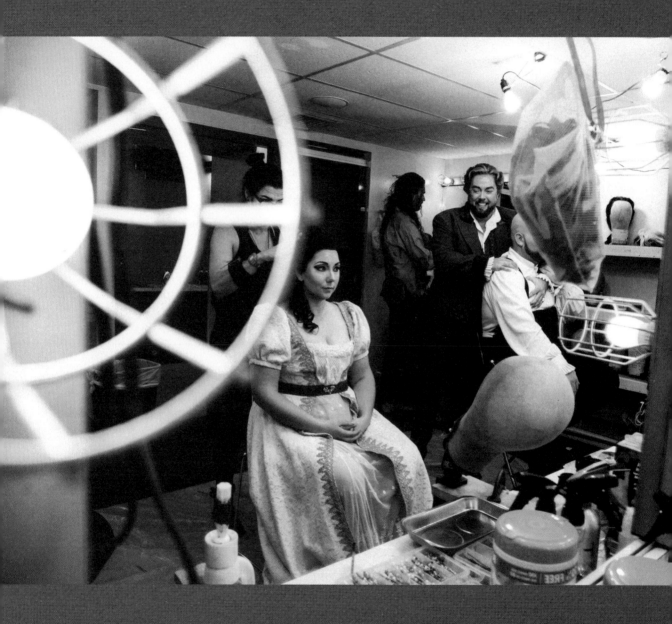

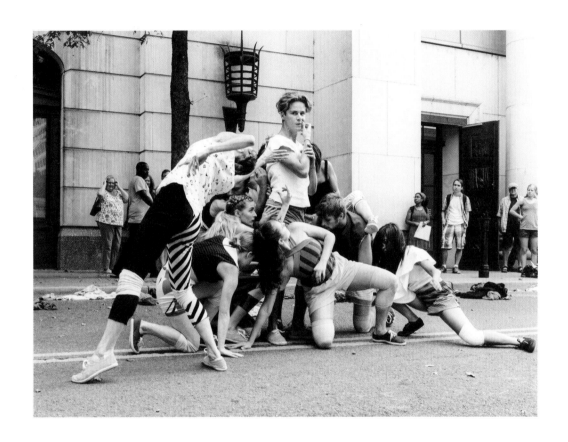

OPPOSITE: The cast of *Tosca* preparing to perform with the Nashville Opera at the Tennessee Performing Arts Center.

∼

ABOVE: New Dialect dance company performing on Church Street, in front of the Nashville Public Library.

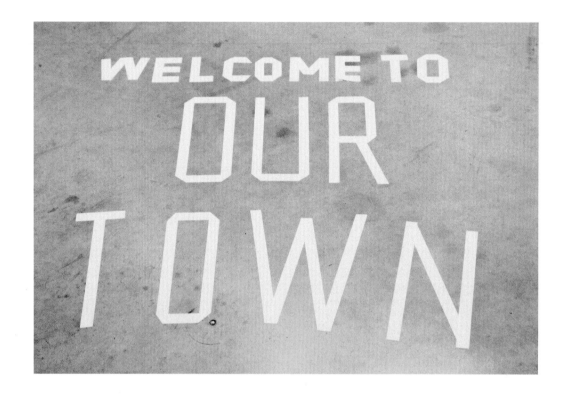

ABOVE: Artist Bryce McCloud mixes up notions of selfies, public art, and being a part of community in Our Town, a project that encourages people to make self-portraits and share them with strangers. Welcome!

∽

OPPOSITE: McCloud at his company, Isle of Printing.

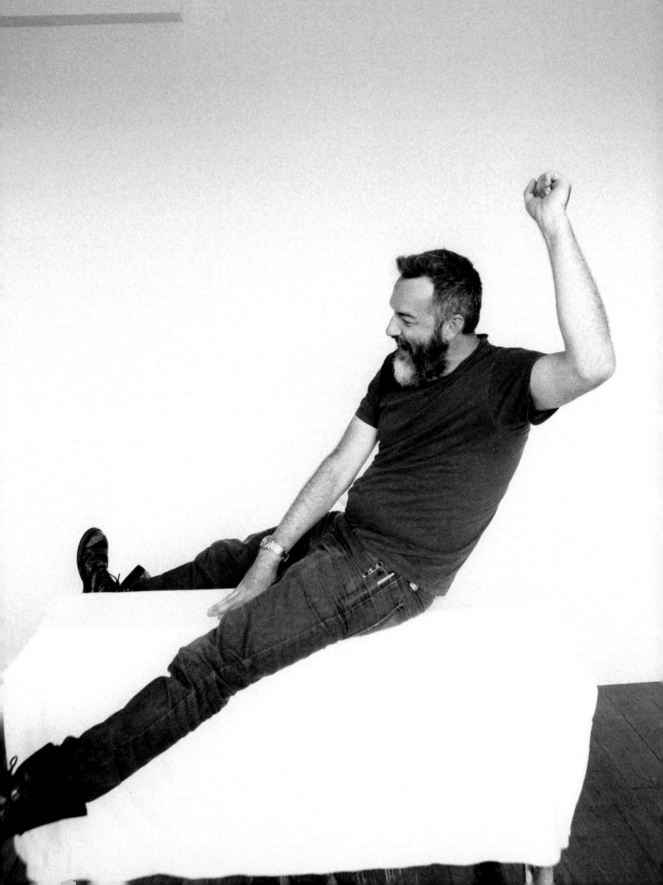

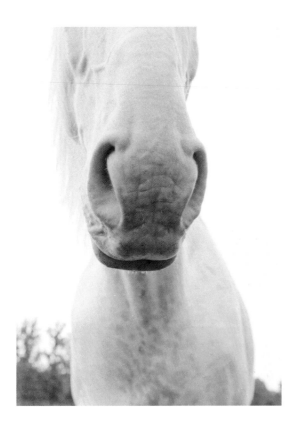

ABOVE: Even as Nashville has grown into a thriving urban center, horses and our love for them still define us. Whether it's the thriving equestrian scene, weekend polo matches, the work horse who helps round up the cattle, or the pet horse ridden in the yard, we cannot do without them.

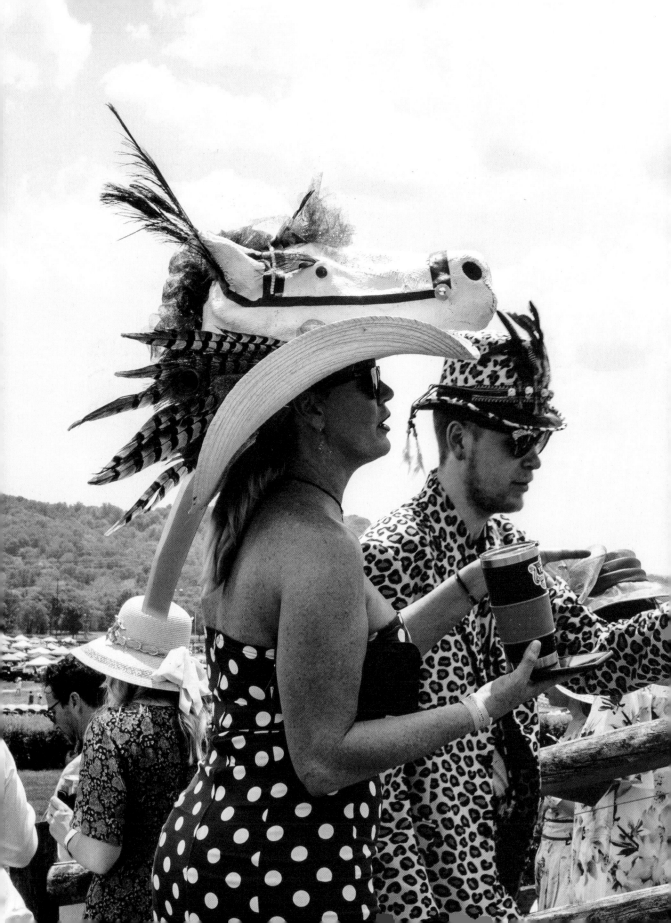

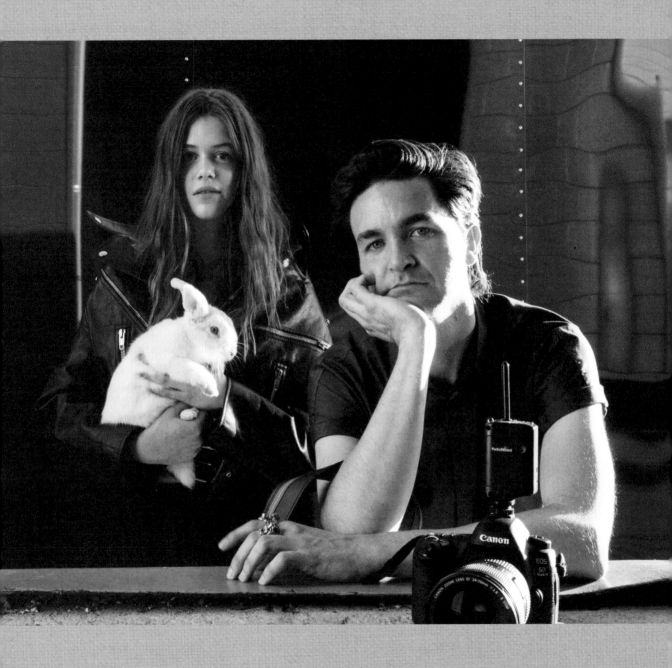

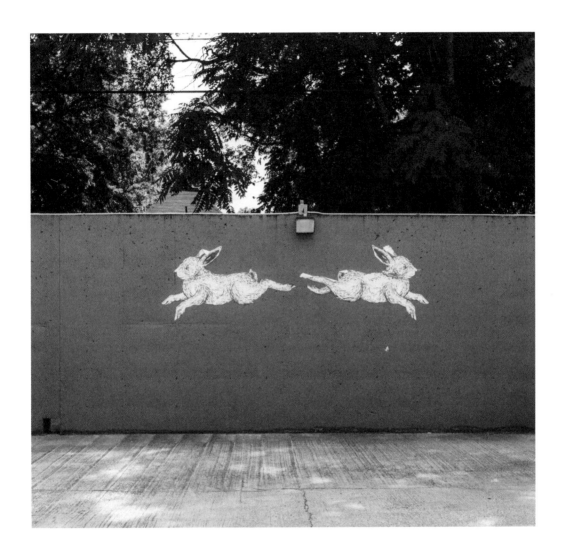

OPPOSITE: Fashion photographer Brett Warren and model Ella Miller.

~

ABOVE: *The Rabbits of East Nashville*, one of artist Emily Elizabeth Miller's temporary, biodegradable murals.

OPPOSITE: Crooner Nikki Lane in a chain-stitched denim jacket of her own design.

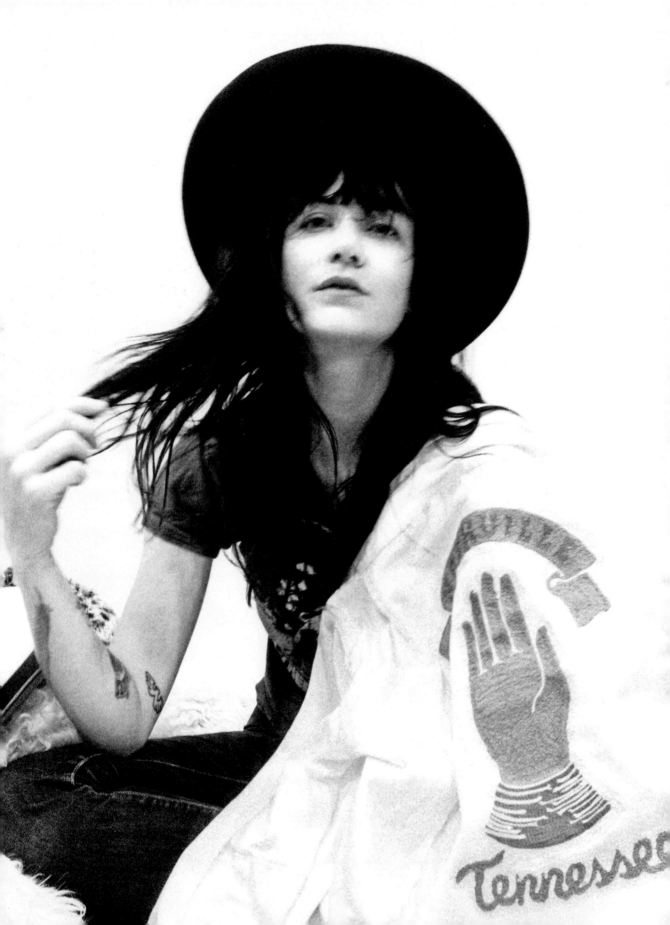

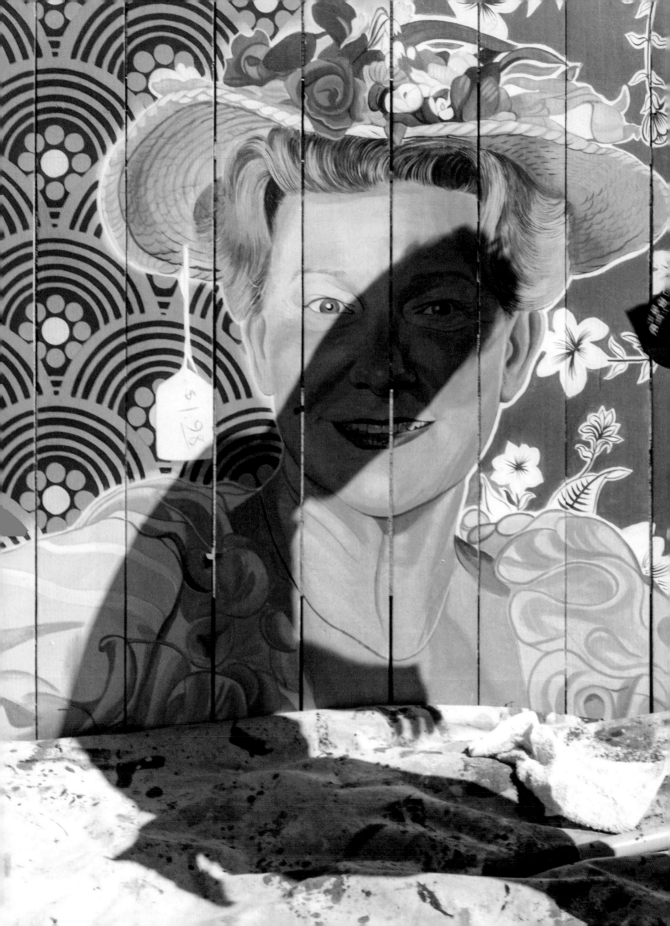

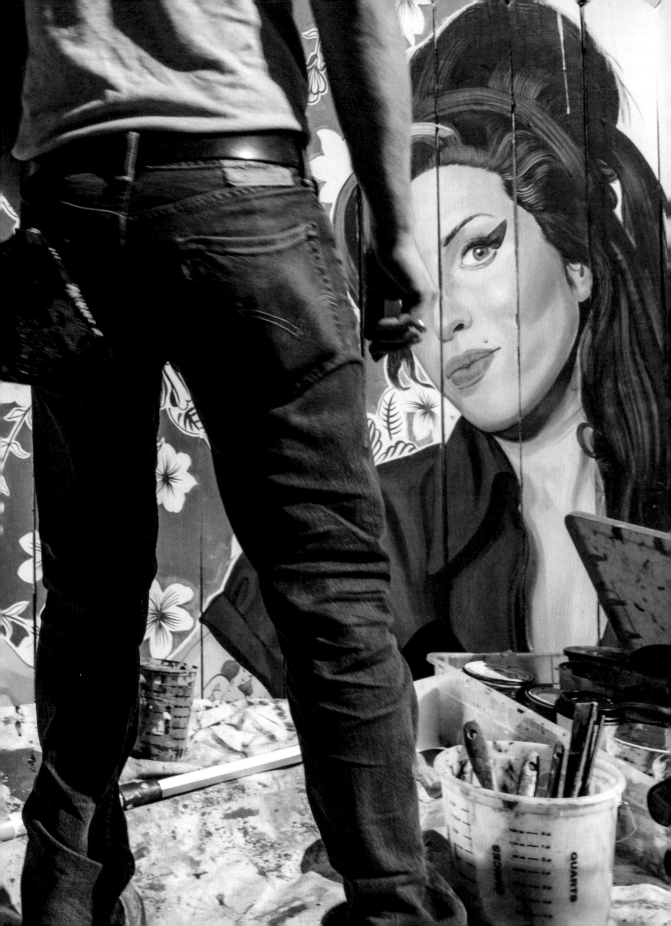

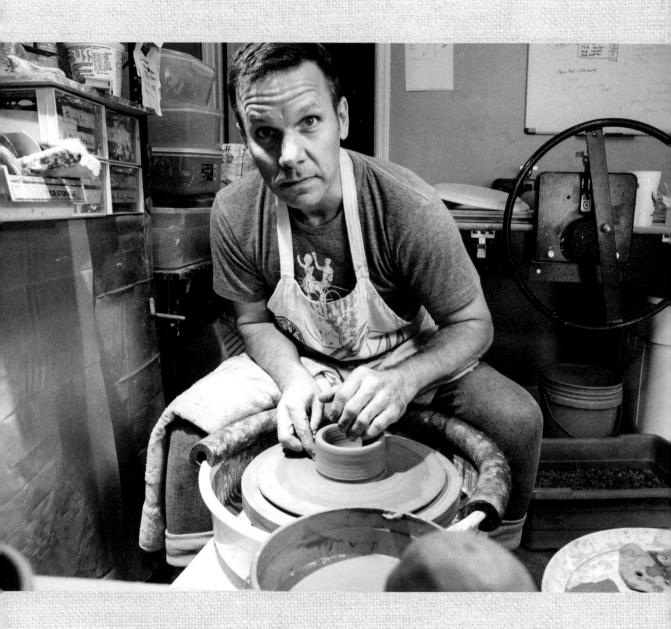

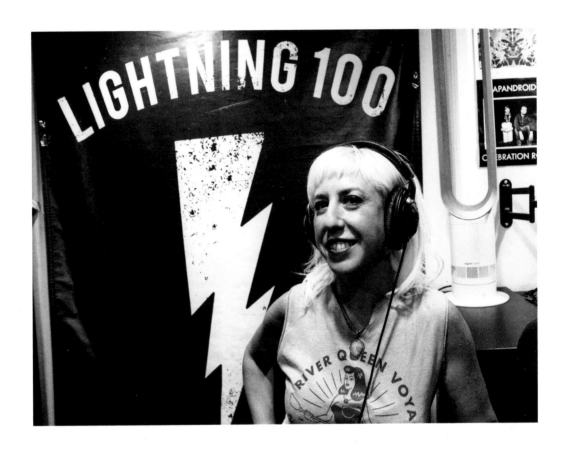

PAGES 92-93: Minnie Pearl and Amy Winehouse, painted by Scott Guion.

～

OPPOSITE: Sculptor John Donovan makes art, but he also makes bespoke dinnerware for many of Nashville's most celebrated restaurants.

～

ABOVE: DJ Annie Klaver, Lightning 100.

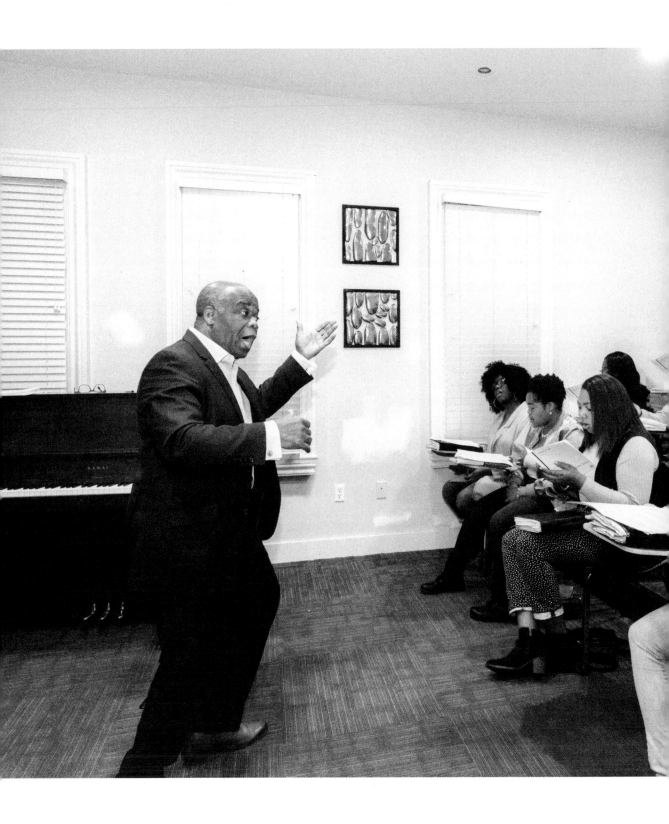

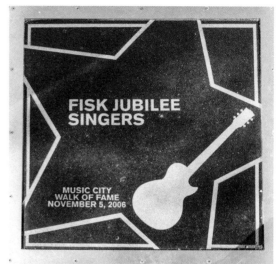

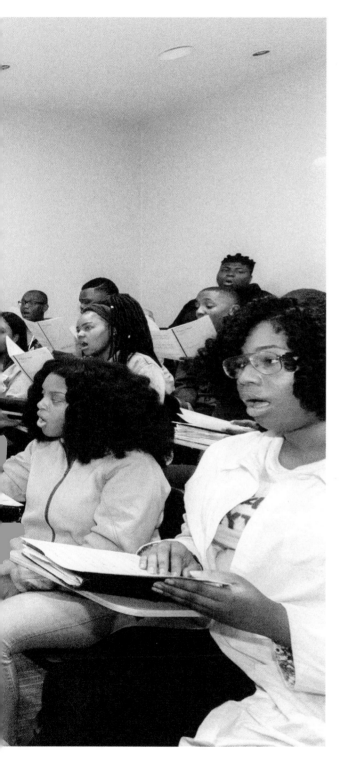

LEFT: The Fisk Jubilee Singers was established as this country's premier student choral ensemble in 1871. Formed to raise money for the school, they originally sang along the path of the Underground Railroad. They have been making beautiful music continuously ever since.

～

ABOVE: The Fisk Jubilee Singers' star on the Music City Walk of Fame.

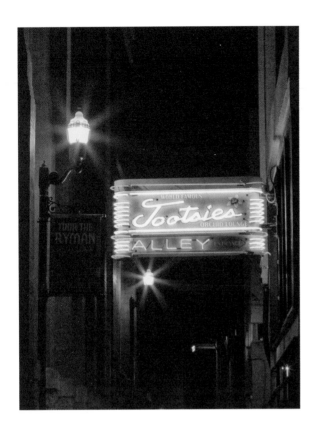

ABOVE: Back in the day, when musicians couldn't drink in the Grand Ole Opry, they could slip across the alley to Tootsie's Orchid Lounge to have a quick shot between sets.

～

RIGHT: Artist Herb Williams is best known for his sculptures made entirely of crayons.

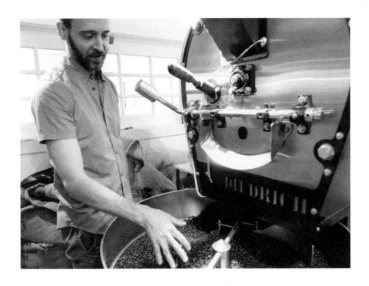

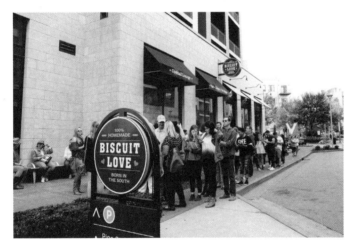

TOP: Coffee roasting at Crema.

～

BOTTOM: Born in a food truck, Biscuit Love now has two brick-and-mortar locations. The biscuits are light, flaky, and piping hot.

～

OPPOSITE: Las Paletas, maker and purveyor of gourmet Mexican popsicles, was one of the first businesses to revitalize the now-packed 12 South district.

las Paletas

Cream
Raspberry Choc. Chip
Mocha
Avocado
Cookies
Cinnamon
STRAWBERRY BANANA CREAM
Chocolate Choc. Chip

Banana Cream
Mexican Caramel
BUTTER PECAN
Coconut

Sugar-Free
ineapple + Mixed Berries w/ Stevia
Strawberry Banana w/ Stevia

Other
• NON-DAIRY GOLDEN MILK
• NON-DAIRY CHOCOLATE

Chiquitas
• Coconut
• MEXICAN C
• Pineapple Ra
• LIME

Inst
@LASPA
#Laspa
SEE OUR
DAILY MENU: @LASP

Fruit
• Mandarin
• PINEAPPLE BLUE
• Strawberry Blu
• STRAWBERRY
• Mango
• Strawberry Pineapple
• WATERMELON
• PINEAPPLE RAS
• Cantaloupe
• Pineapple w/ Ch

Price Li
• paleta
• chiquita
• chocolate di
• reezer bag
• ottled wate
• t cards a
• cates new
• tering &
Las Na

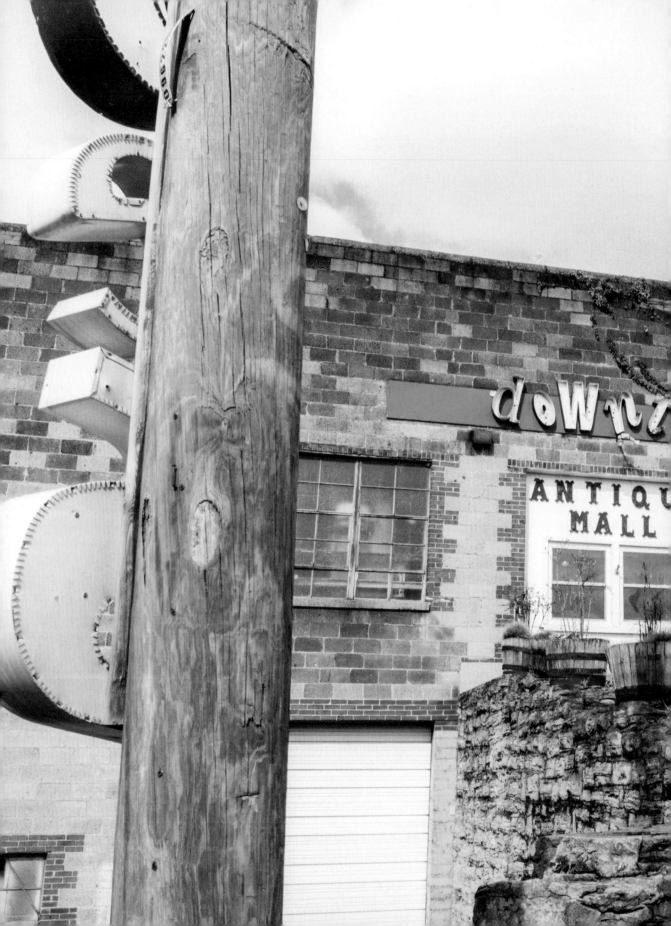

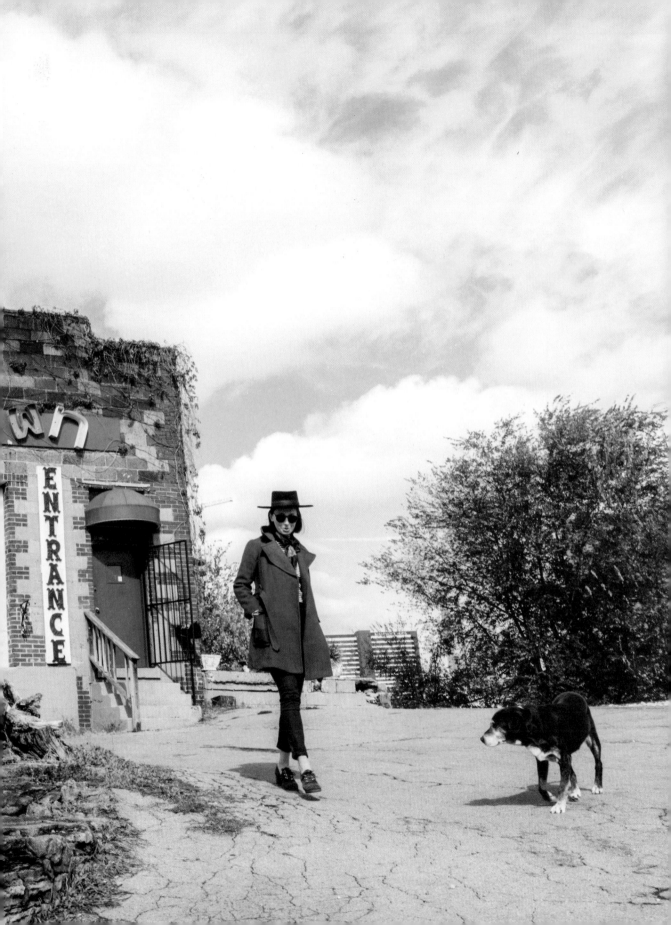

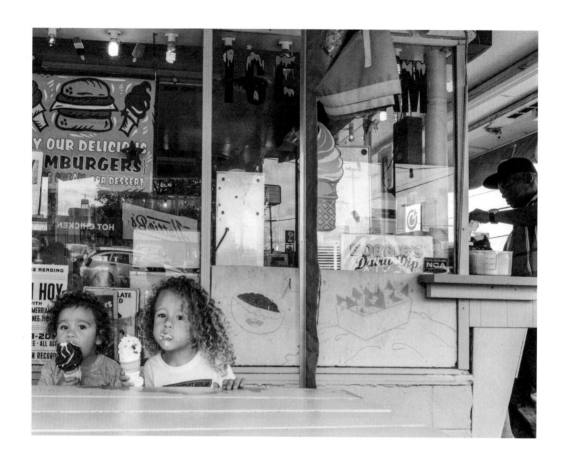

PAGES 102-103: Lera Lynn, queen of post-Americana music, with her dog, Ruby, at the Downtown Antique Mall.

～

ABOVE & OPPOSITE: Bobbie's Dairy Dip has been in the same location since 1951. That's also about how long people have been circling the block, looking for a parking place.

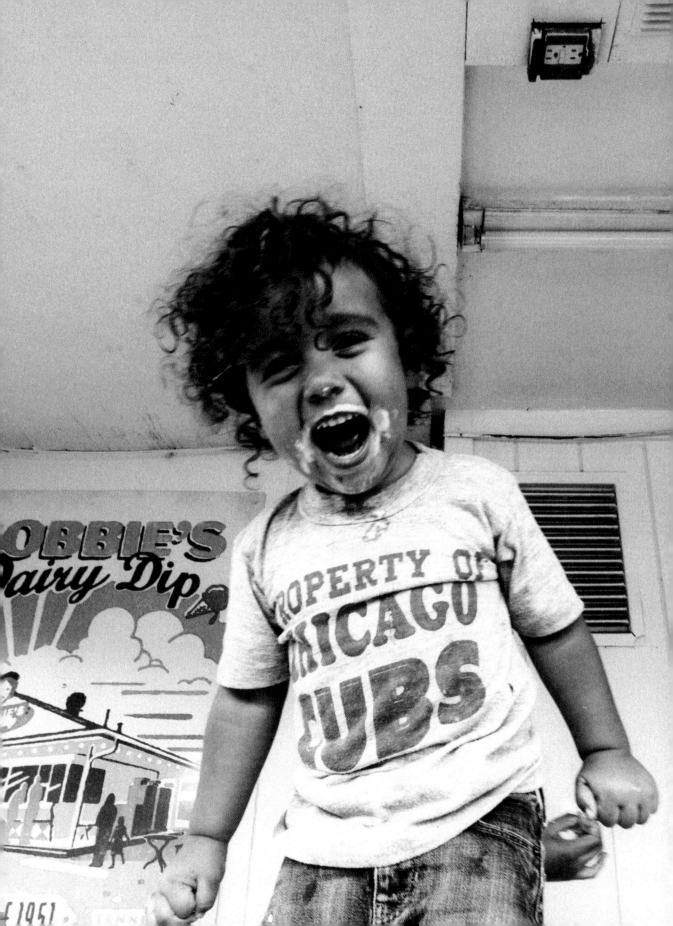

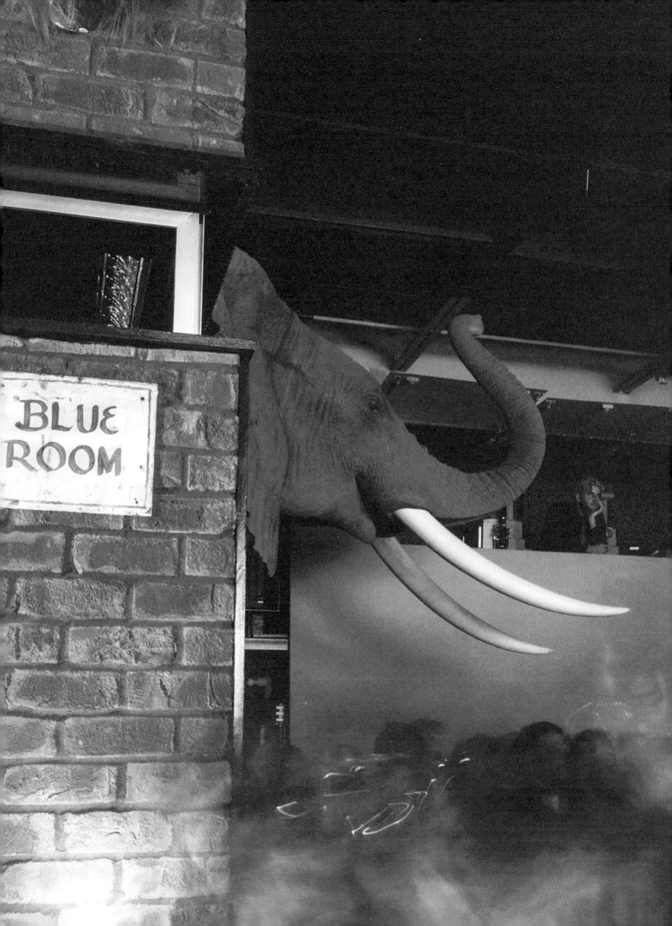

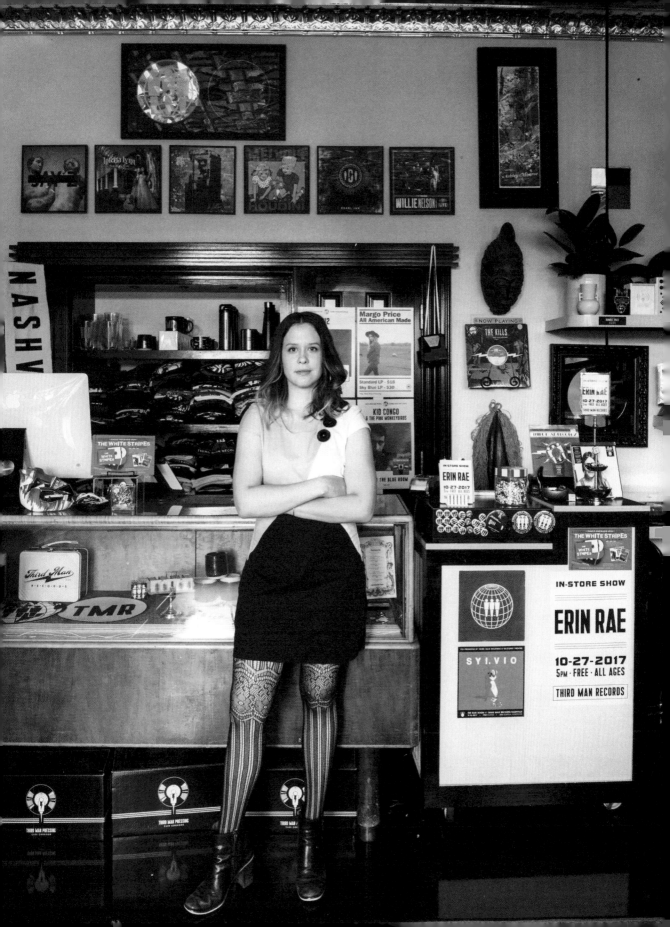

PAGE 106: The Blue Room is Third Man Records's unique, curved wall club that plays host to artists of all stripes.

❧

PAGE 107: Third Man's signature yellow, black, and blue color scheme saturates every aspect of the compound, including "Rabble Rouser" Chloe Cooper.

❧

OPPOSITE: Filmmaker and painter Harmony Korine with his daughter, Lefty.

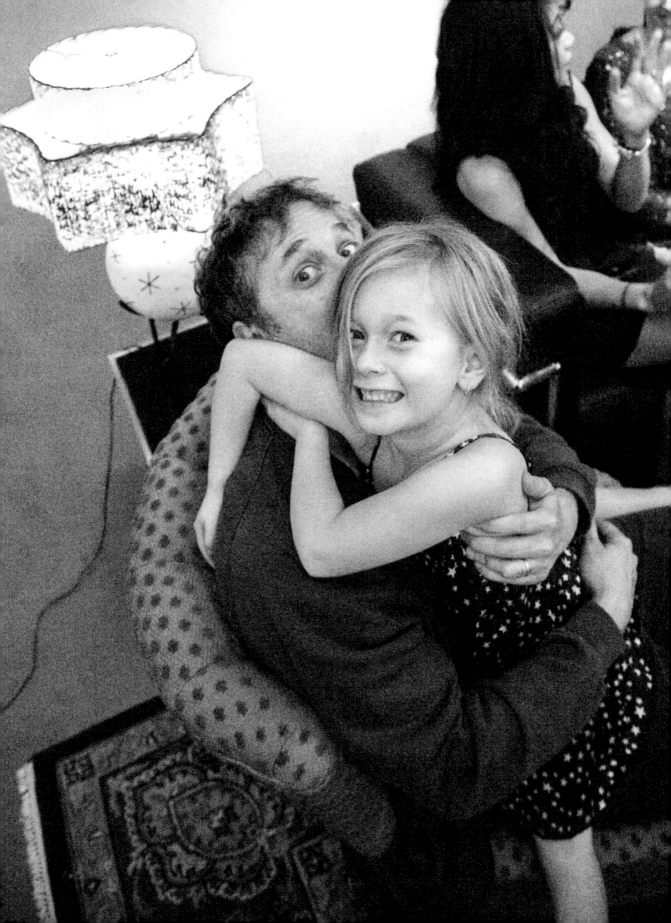

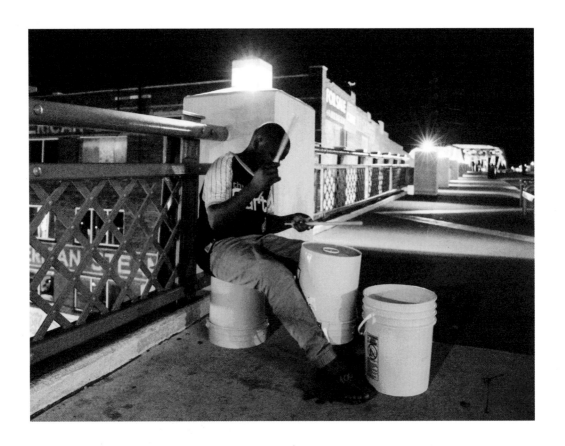

ABOVE: DIY.

〜

OPPOSITE: Woodland Studios
was founded in 1966 by Glenn
Snoddy. Willie and Waylon and
Aretha and Loretta and Lynyrd
and Dolly and Tammy and
Merle and Kris and Johnny and
Patsy and Clint and Reba have
all recorded there. The rest of
them too.

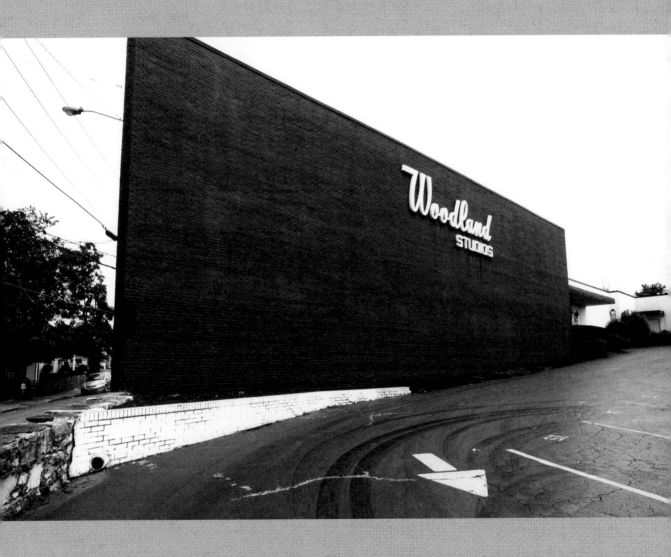

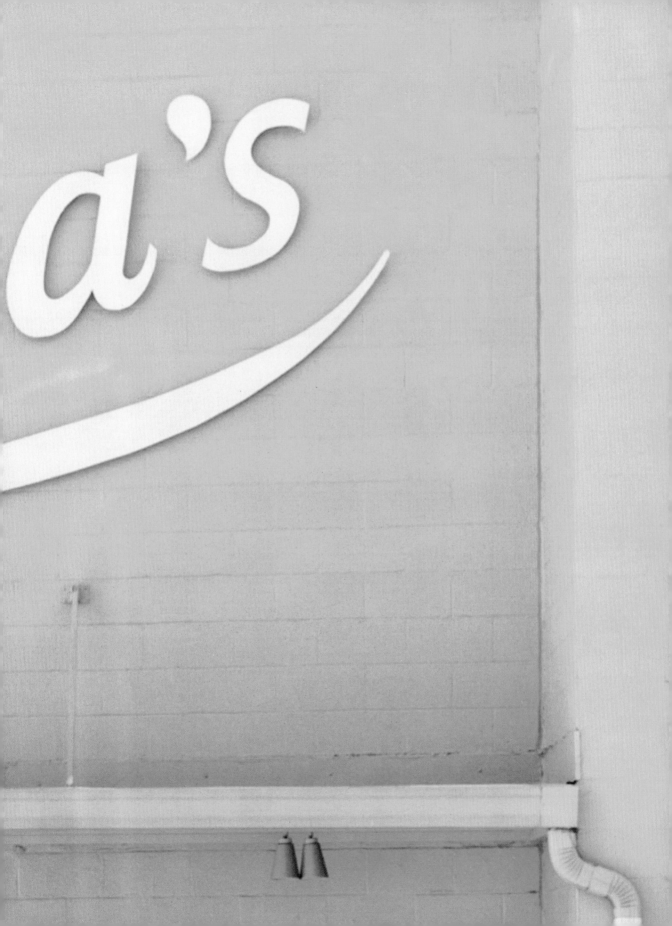

PAGES 112-113: Nashville is full
of florists now, but back in the
day it was all about Emma's. For
many people, it is still all about
Emma's. Open since 1938, it
bills itself as "the superlative
florist." It's right in the center of
town, it's been there forever, and
it has an amazing pink building.

&

ABOVE: Virginia creeper.

&

OPPOSITE: High Garden tea,
Woodland Avenue.

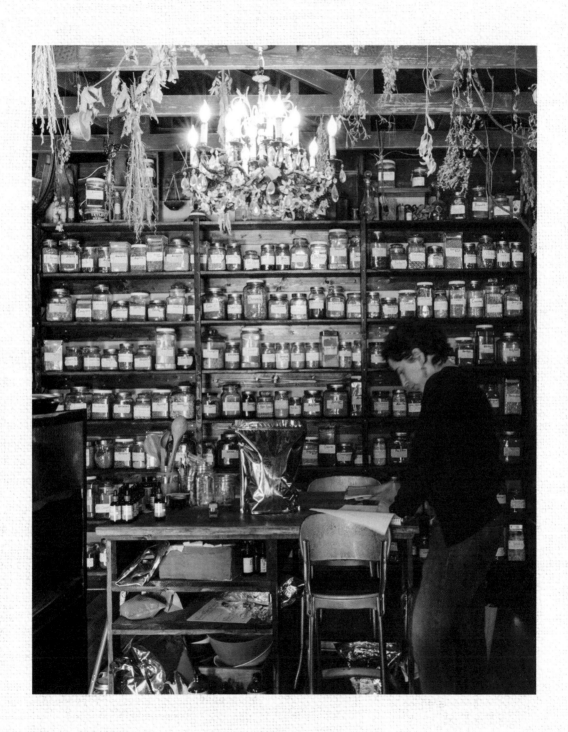

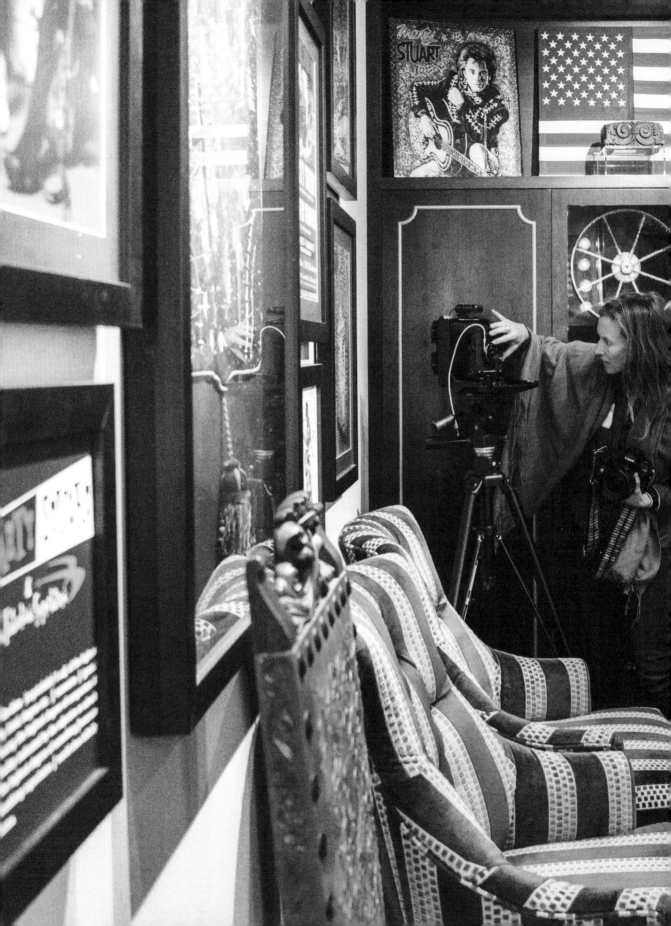

PAGES 116-117: Caroline Allison prepares to photograph Marty Stuart in his dressing room at the Grand Ole Opry, as fans look on.

~

RIGHT: Amanda Shires and Jason Isbell backstage before a sold-out performance. Incidentally, they are both voracious readers.

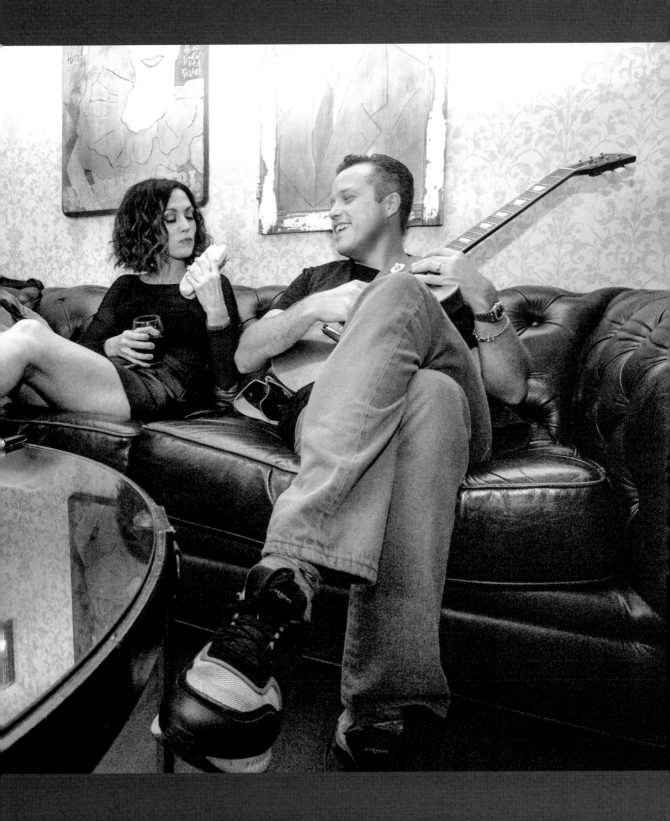

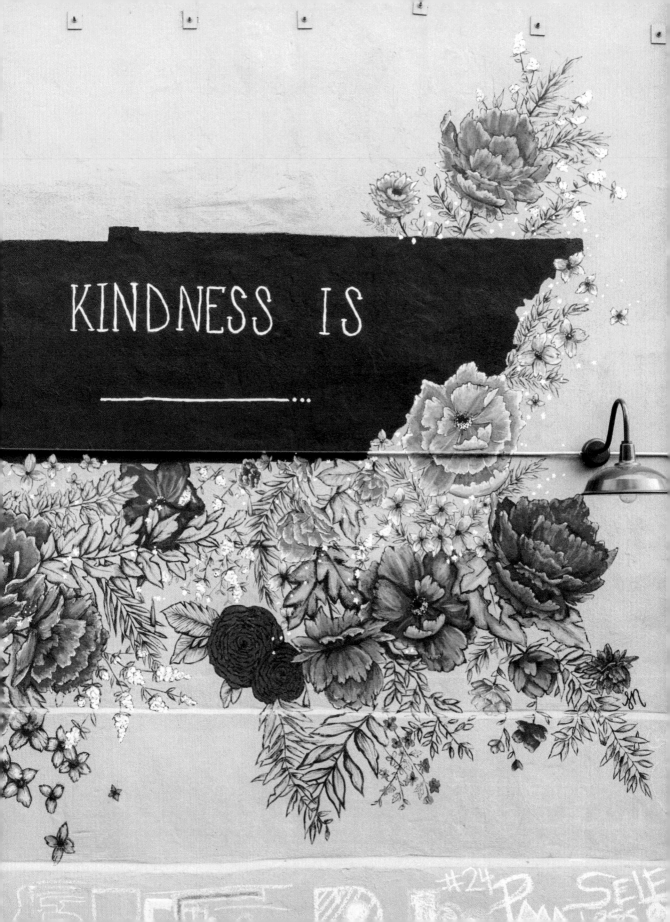

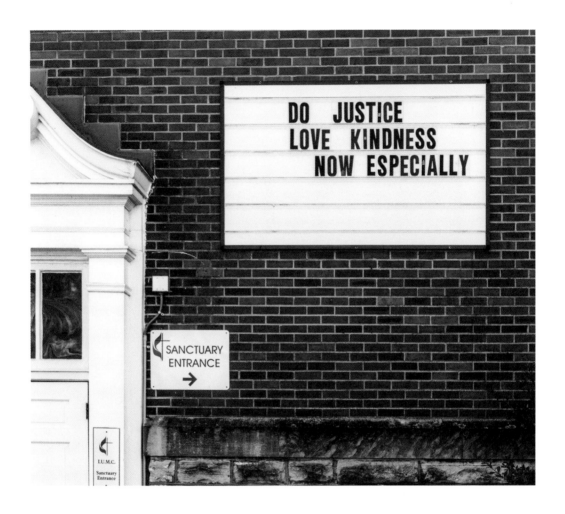

OPPOSITE: Rebekah Rinehart and Sarah Gail Nelson created the fill-in-the-blank *Kind Mural* in Germantown as part of a public-art initiative. People are encouraged to stand in front of the mural and share their thoughts on kindness, either in videos, photographs, or just by saying kind things.

～

ABOVE: Church marquee.

ABOVE: Becca Stevens, the founder of
Thistle Farms, a company whose mission
is to heal, empower, and employ women
who are survivors of human trafficking,
prostitution, and addiction.

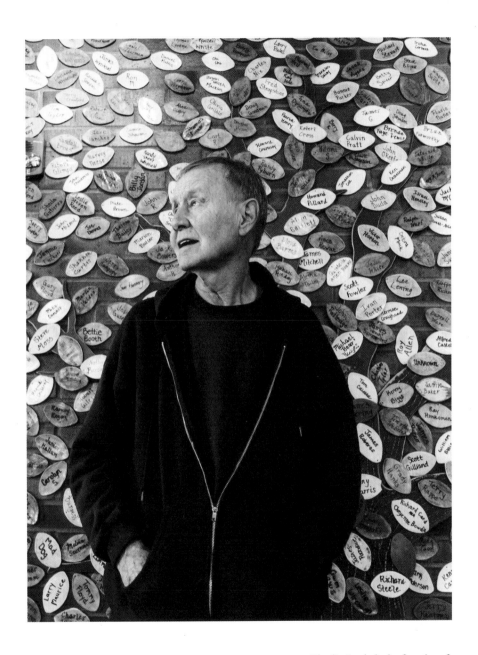

ABOVE: Charlie Strobel, the founder of the Campus for Human Development. The leaves of the tree represent the homeless men and women who have died in Nashville.

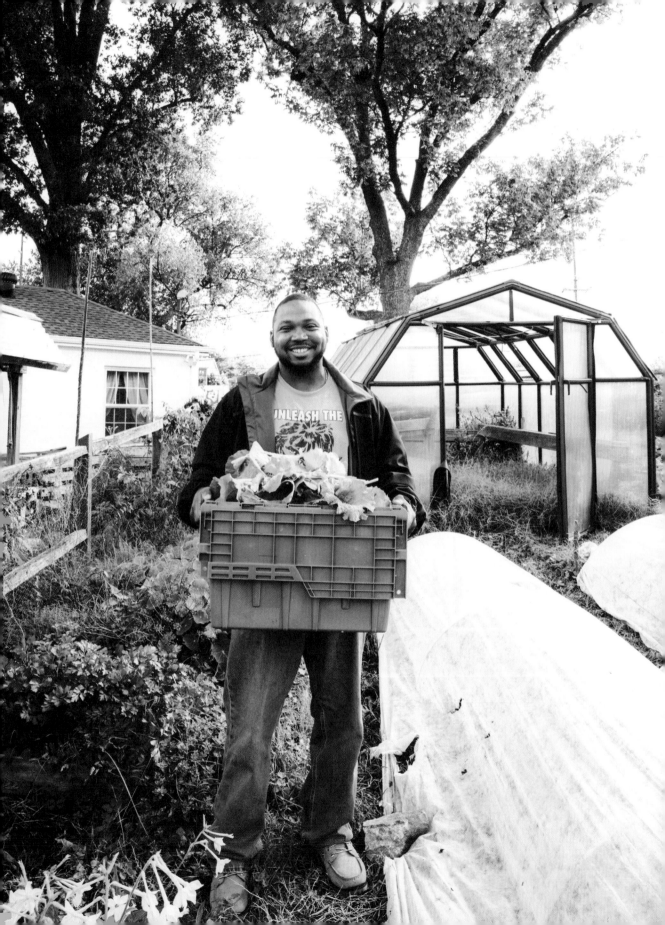

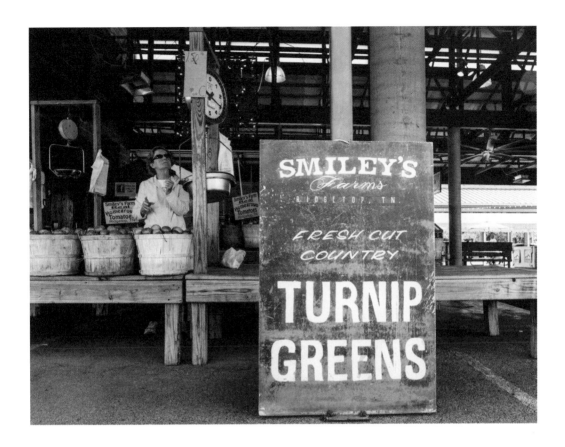

OPPOSITE: Farmer Tyler works his grandfather's kale farm, bringing his crops to the Nashville Food Project to help serve the city's hungry.

～

ABOVE: Smiley's turnip greens, at the Nashville Farmers' Market. Smiley's Farm has been providing fresh tomatoes, sweet corn, stringless pole beans, and their famous turnip greens for six generations. They claim to have cooked the world's largest pot of turnip greens.

～

RIGHT: The mission of the Nashville Food Project is to bring people together to grow, cook, and share nourishing food, with the goals of cultivating community and alleviating hunger.

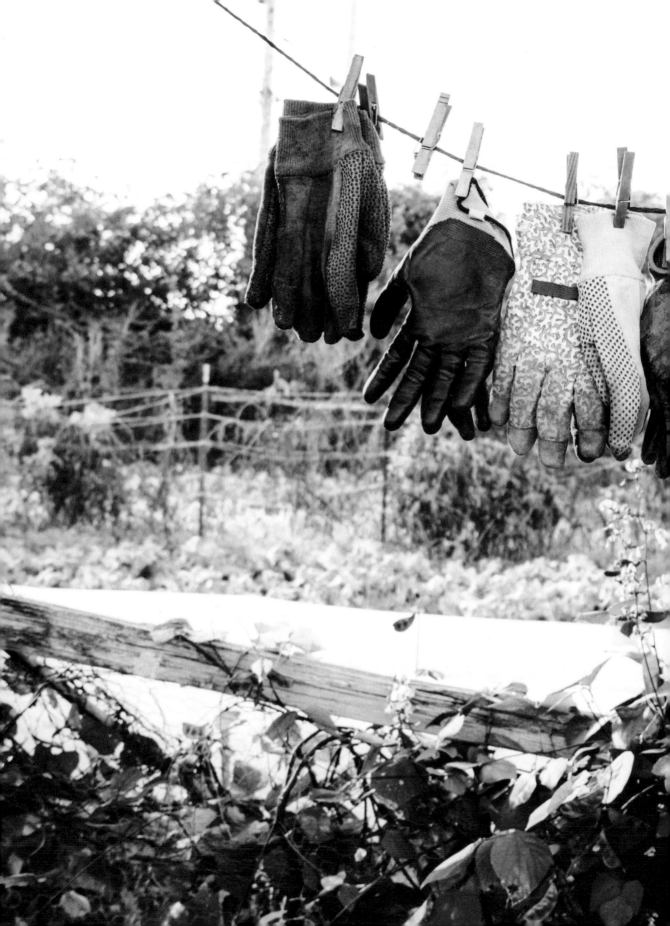

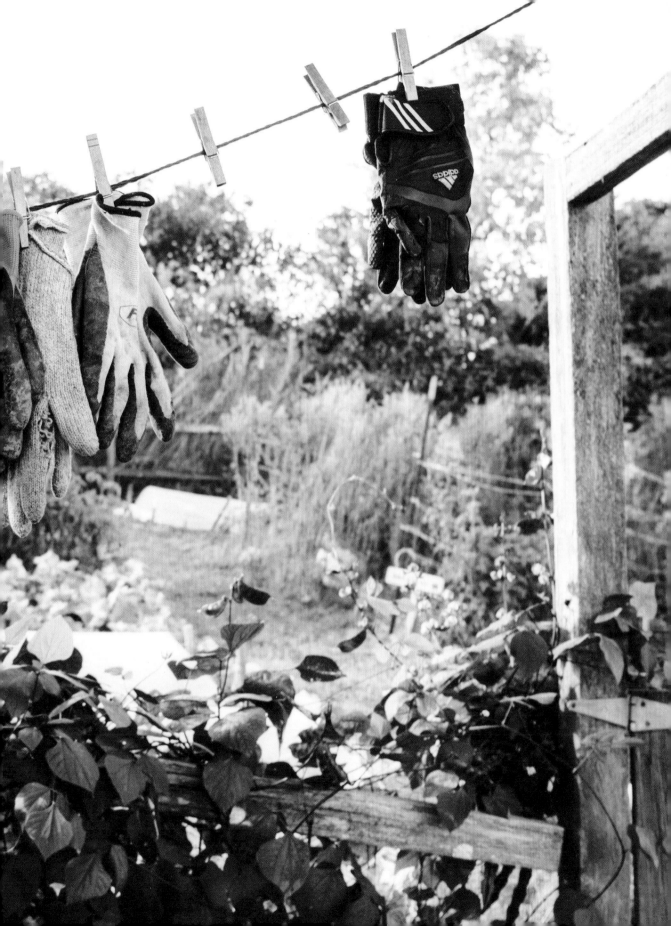

PAGES 126-127: Nashville Food Project
workers hang their gloves to dry after
picking produce.

～

RIGHT: Comfort.

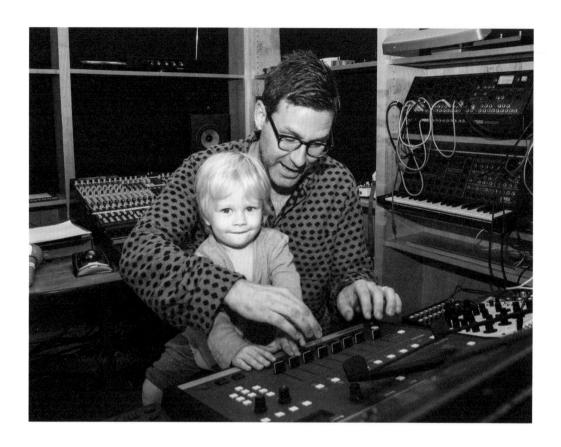

ABOVE: Jamie Lidell is a genius musician
from England who could have lived
anywhere in the world. He moved to
Nashville. Here he is pictured with his
son, Julian.

∾

OPPOSITE: Piano repair, Second Avenue.

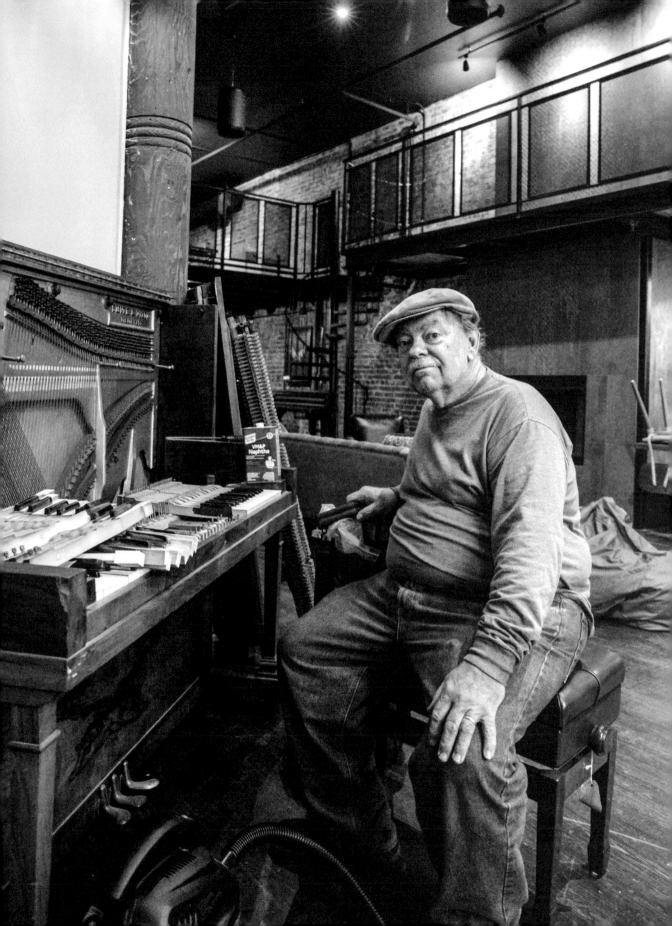

OPPOSITE: **If you're old enough to play a fiddle, you're old enough to busk.**

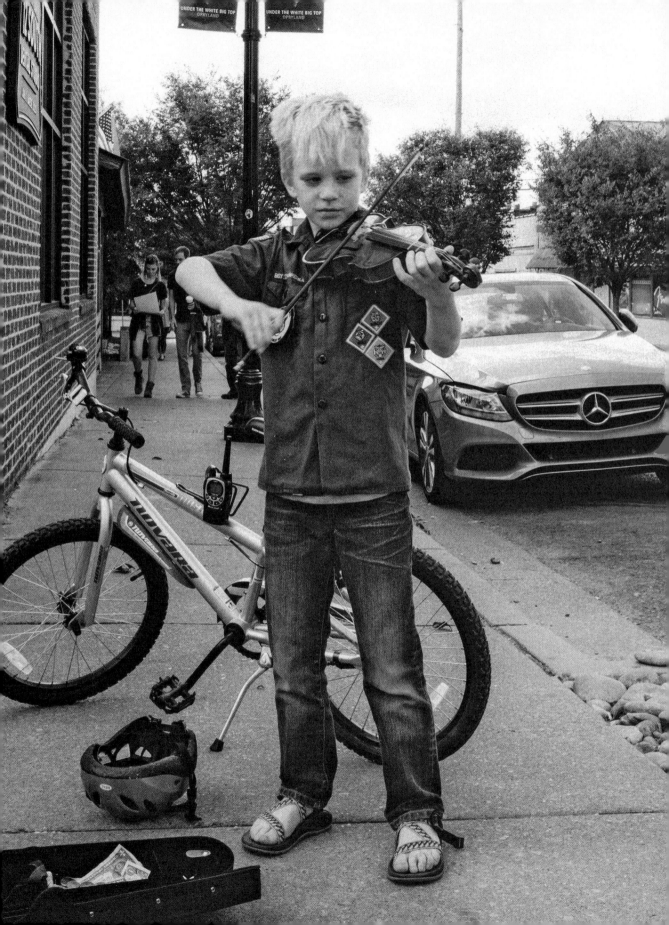

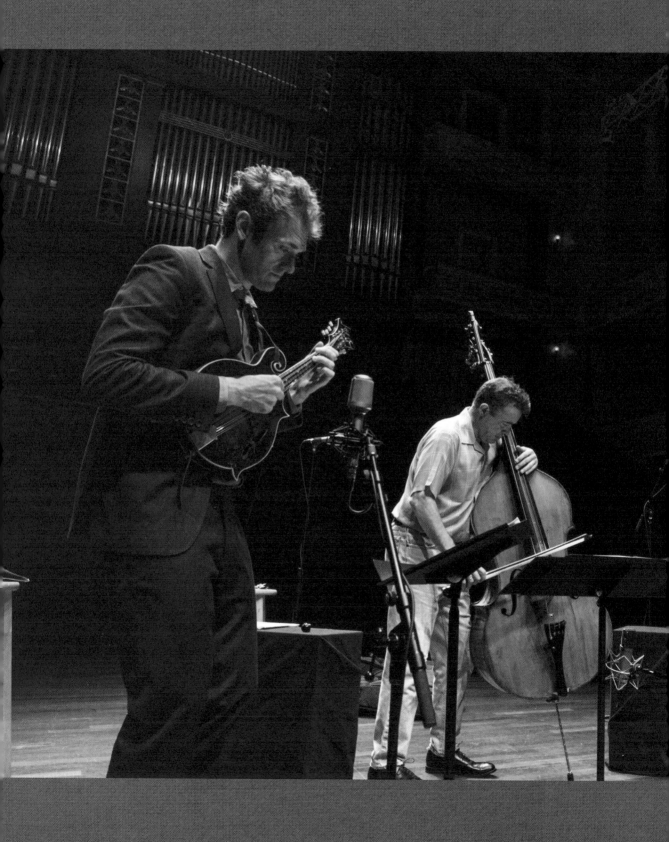

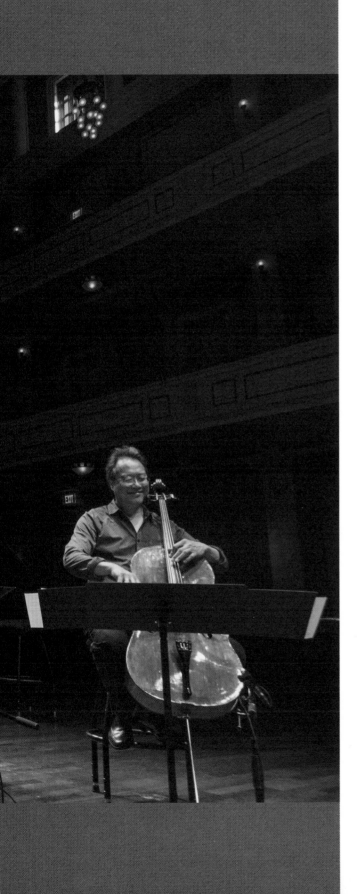

LEFT: Chris Thile (mandolin), Edgar Meyer (bass), and Yo-Yo Ma (cello), rehearsing Bach at Schermerhorn Symphony Center. Yo-Yo stopped by Parnassus Books on his way to rehearsal and played cello for twenty people and then rolled around on the floor with the shop dogs.

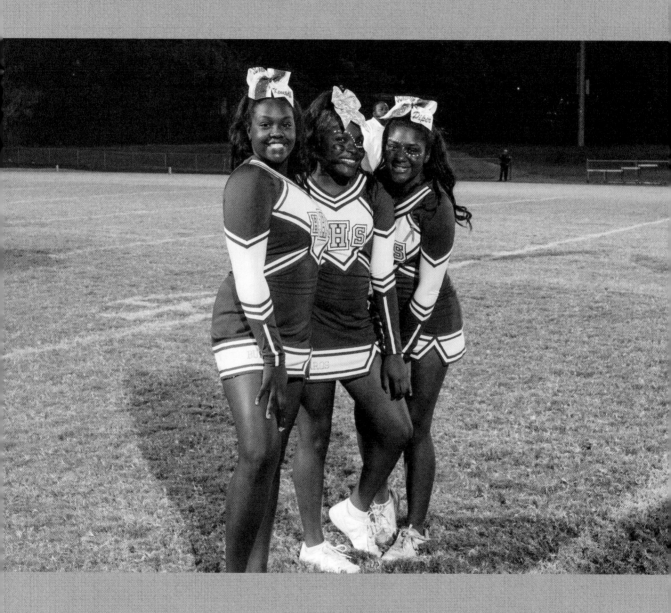

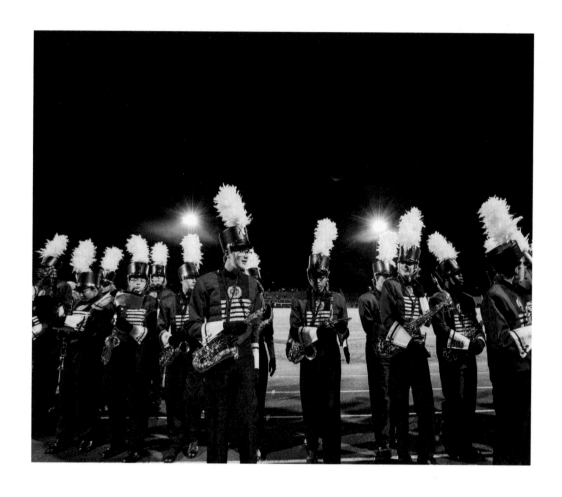

OPPOSITE: Hillsboro High School's cheer
squad. Go Burros!

∿

ABOVE: Hillsboro High marching band.

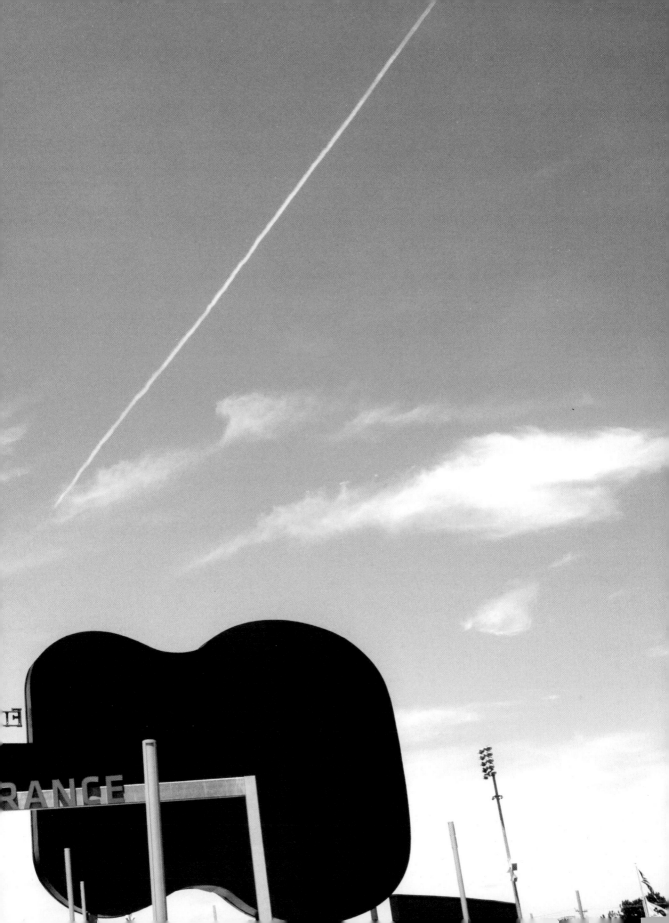

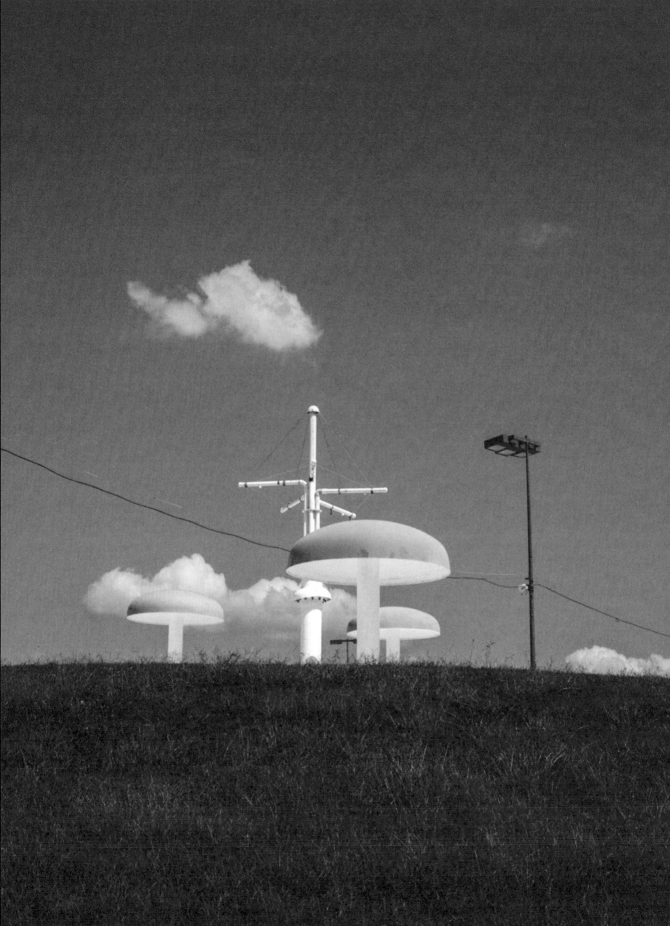

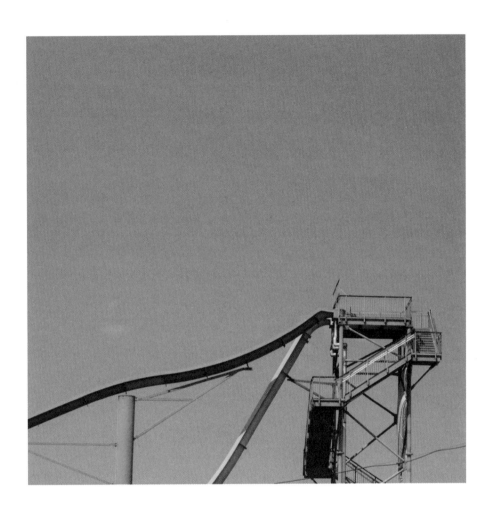

PAGES 138-139: First Tennessee Park, home of the Nashville Sounds. A minor-league team is all a city really needs.

෴

OPPOSITE: Giant mushrooms provide shade at Two Rivers.

෴

ABOVE: Wave Country: water flumes, speed slides, and wave pools. We can't get enough of it.

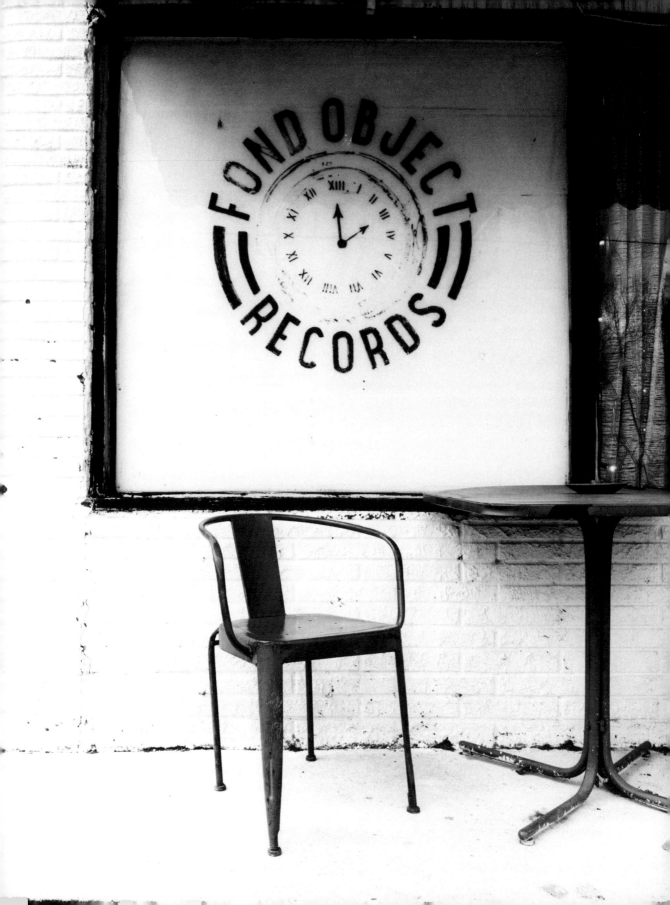

YES

WE DO HAVE THE

LATEST: KURT VILE
* Courtney Barnette +
* MARGO PRICE
* BECK
* BULLY *LANA DEL REY
* OMNI
* PARAMORE

AND MUCH MORE!

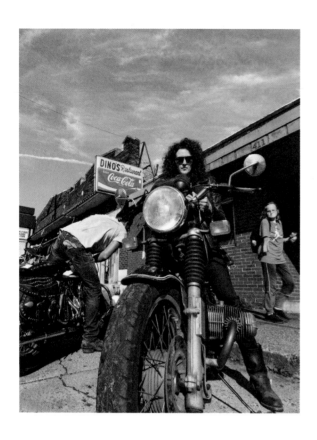

PAGES 142–143: Fond Object Records is a vintage clothing and record store that features a backyard performance space and a very friendly shop goat.

~

ABOVE: Photographer Yve Assad at Dino's, Nashville's oldest dive bar. It's family-friendly until 8:00 P.M.— and just plain friendly after that.

~

RIGHT: Blackbird Assembly is part of the resurgence of motorcycle clubs in Nashville.

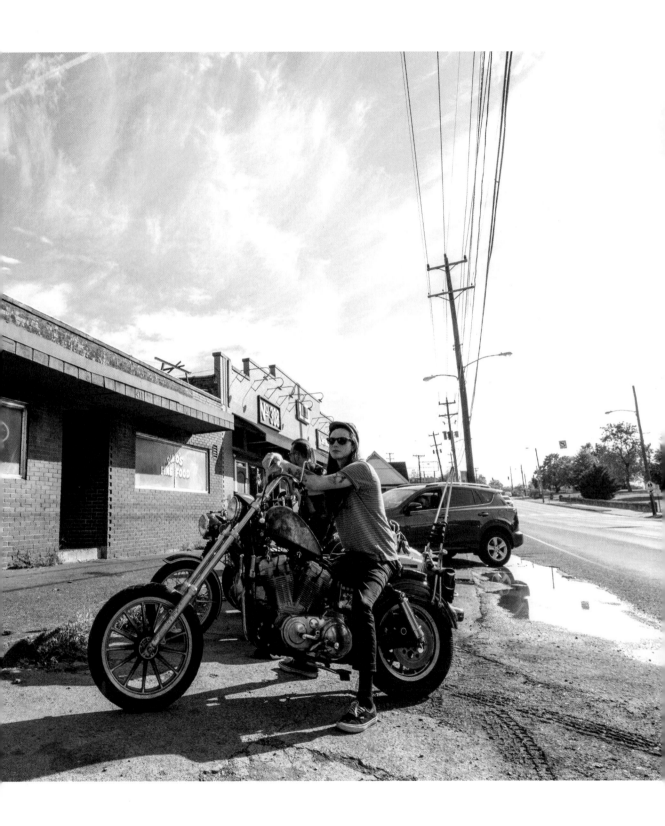

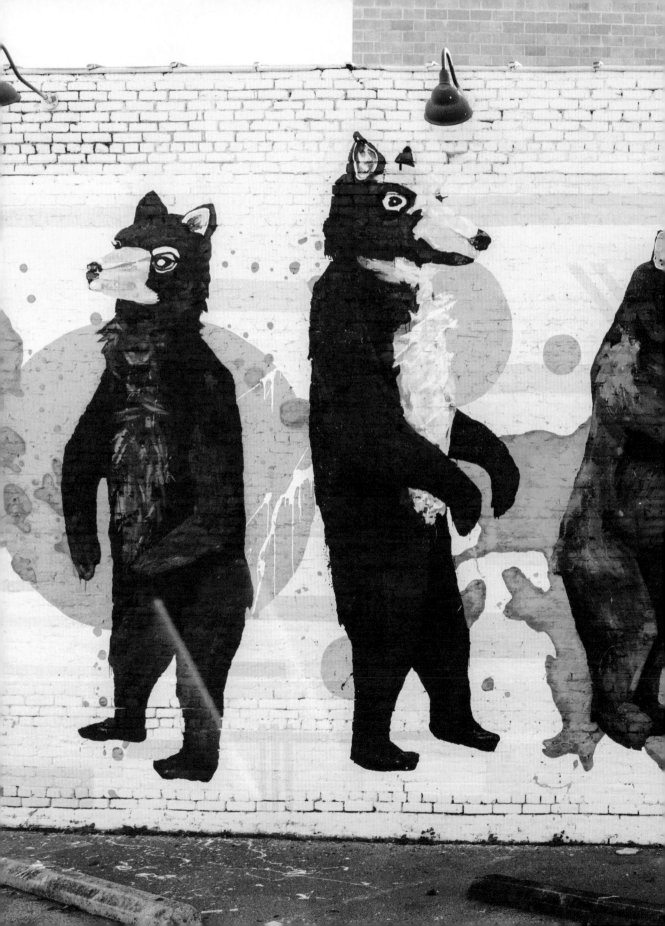

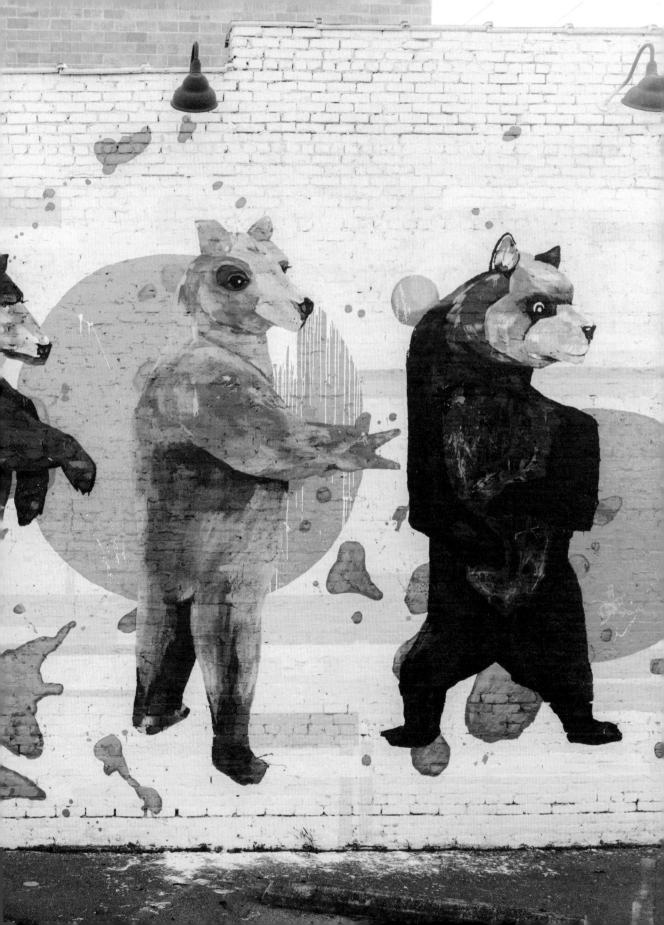

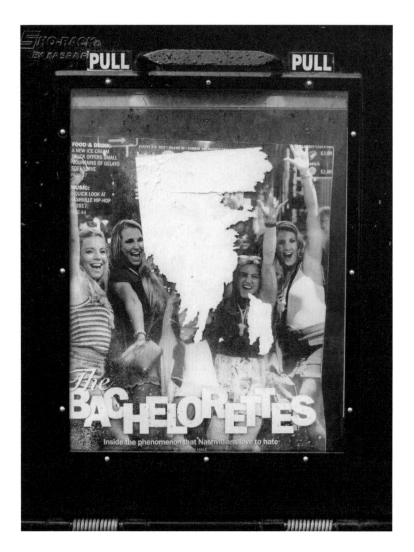

PAGES 146-147: Artist Leah Tumerman says of her *Five Points Bears* mural in East Nashville, "Art should serve society in its capacity to start a conversation." The bears have done exactly that.

∽

ABOVE: The *Nashville Scene* bachelorettes cover.

∽

RIGHT: A Pedal Tavern is a multiseated bicycle you ride with a group, while drinking. Nashville visitors cannot get enough of them.

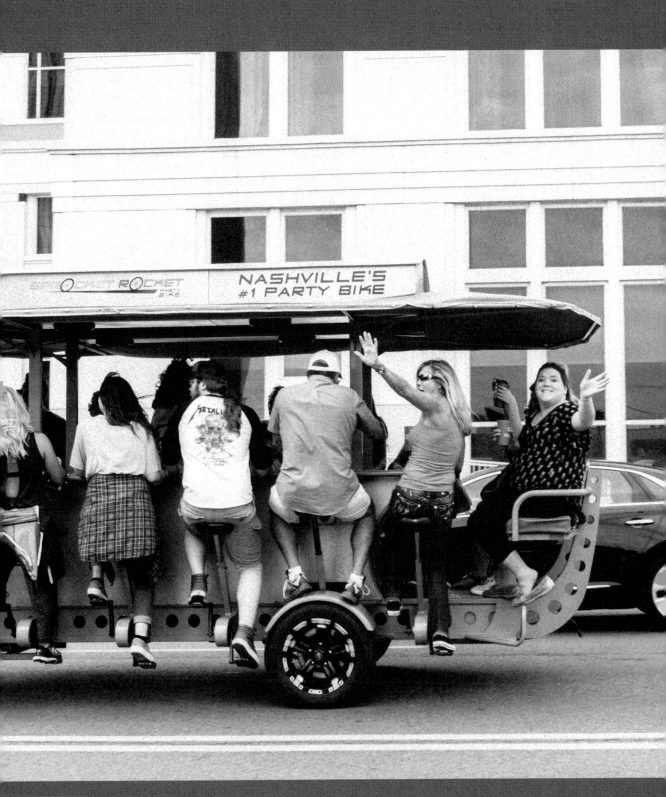

RIGHT: The brass band Halfbrass leads a wedding party.

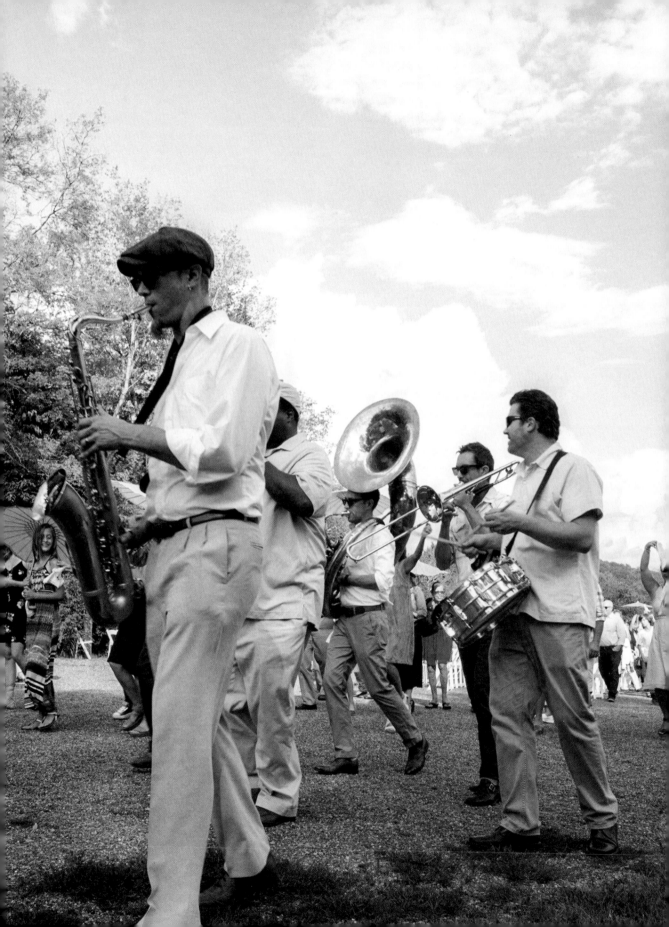

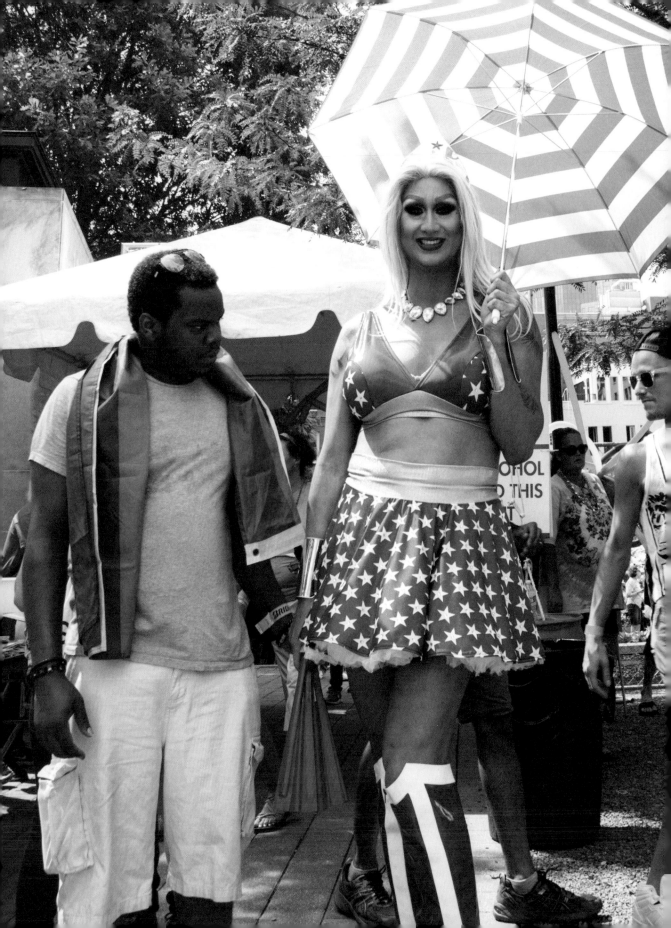

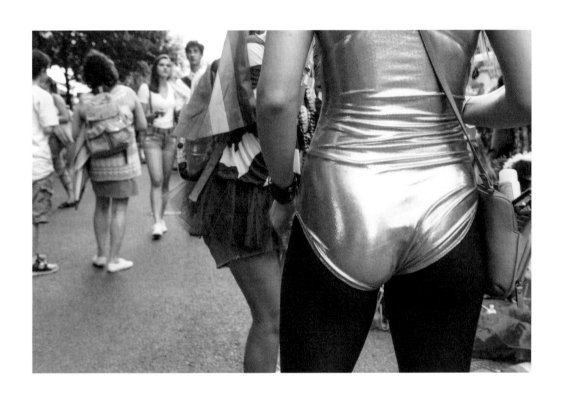

OPPOSITE: Nashville Pride Festival.

~

ABOVE: Practical shoulder bag.

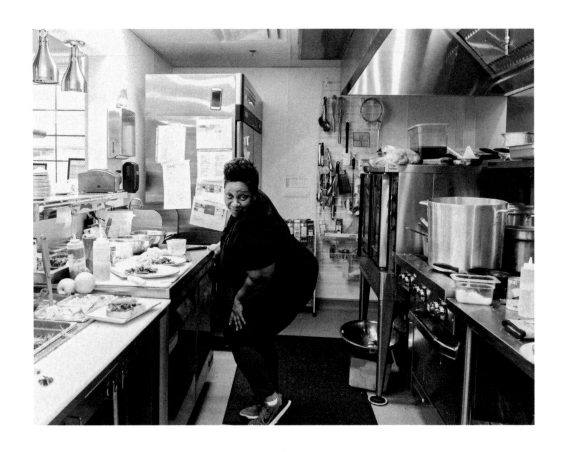

ABOVE: The Café at Thistle Farms offers Nashville's only daily traditional tea service and it sells Thistle Farms's handmade soaps and lotions. Profits from the café and the sale of products help support survivors of sex trafficking and abuse. All programs are staffed by Thistle Farms graduates.

～

OPPOSITE: Thanks to Nashville's public-art initiative, there are now many large-scale murals downtown, some of which can be seen only from the higher floors of other buildings.

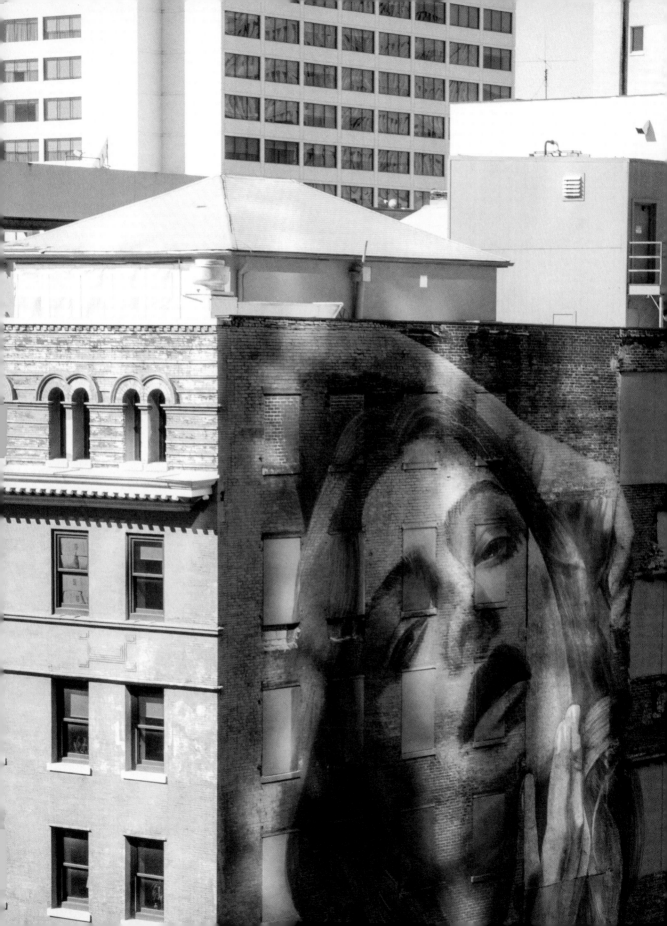

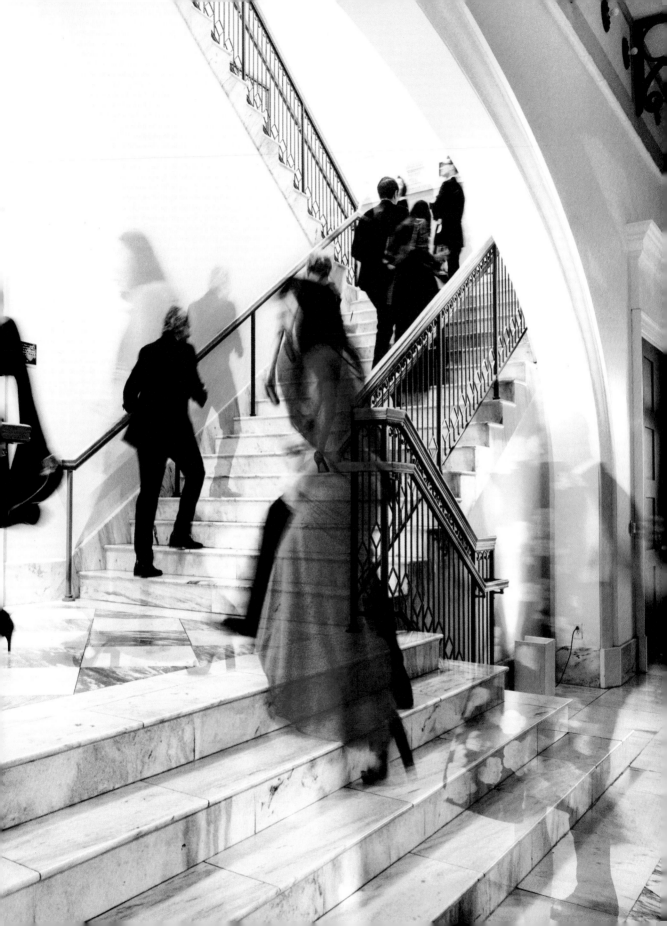

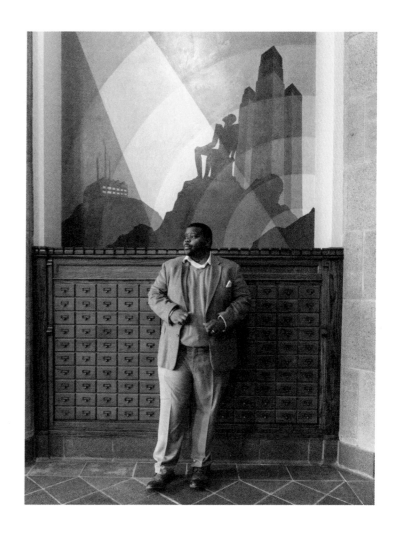

OPPOSITE: Nashville loves charitable galas, called
pay parties, in which money is raised, tuxedos
are worn, and a good time is had by all.

⟿

ABOVE: Jamaal Sheats, director and curator of the
Fisk University Galleries, in front of an Aaron
Douglas mural of the Harlem Renaissance.

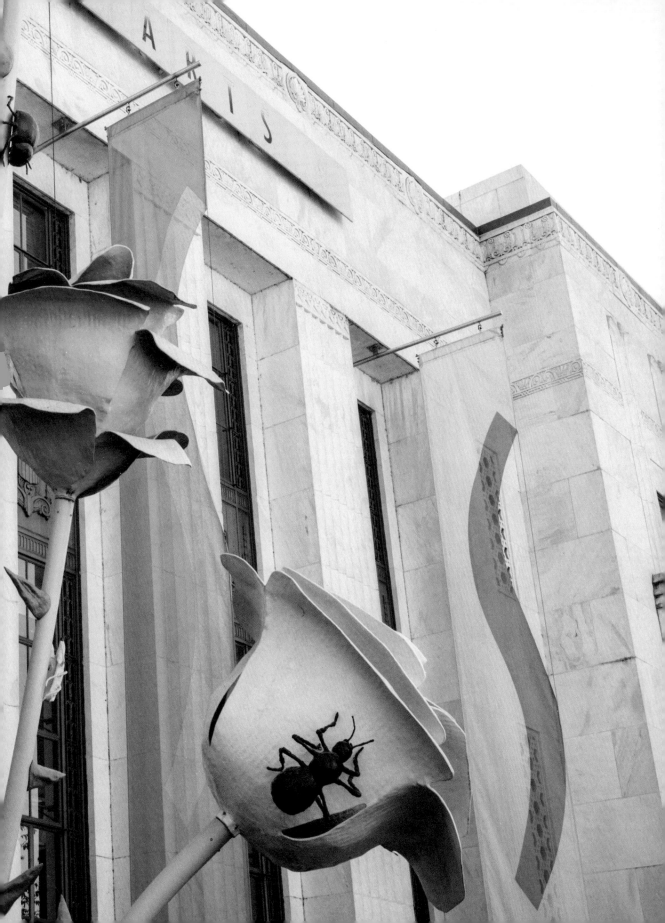

PAGES 158-159: The Frist Center for the Visual Arts.

∿

OPPOSITE: Founded in 1991, Fat Mo's consistently
wins Best Cheeseburger whenever cheeseburgers
are judged around town. It just goes to show that
great burgers can be born on small grills.

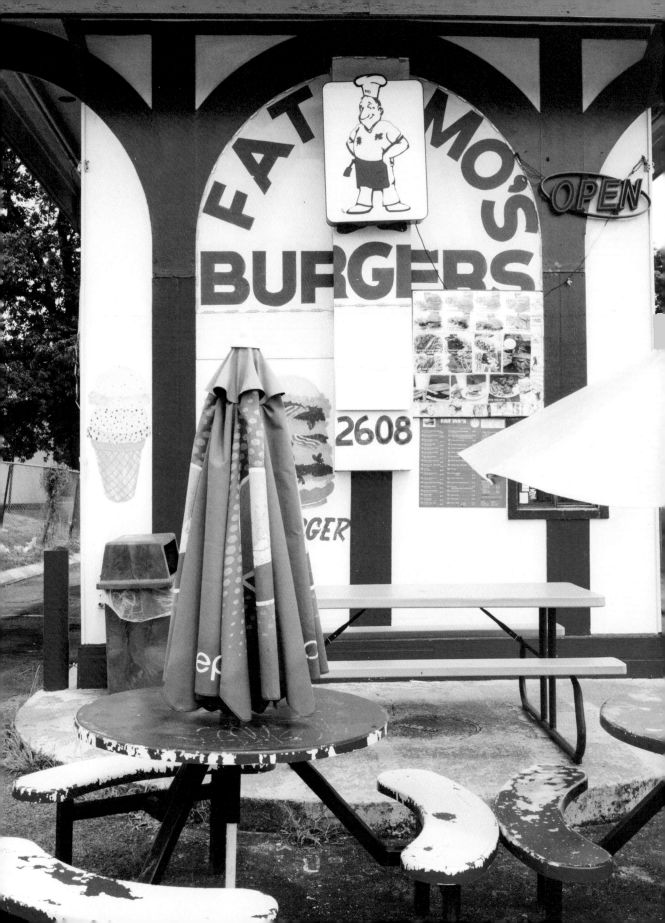

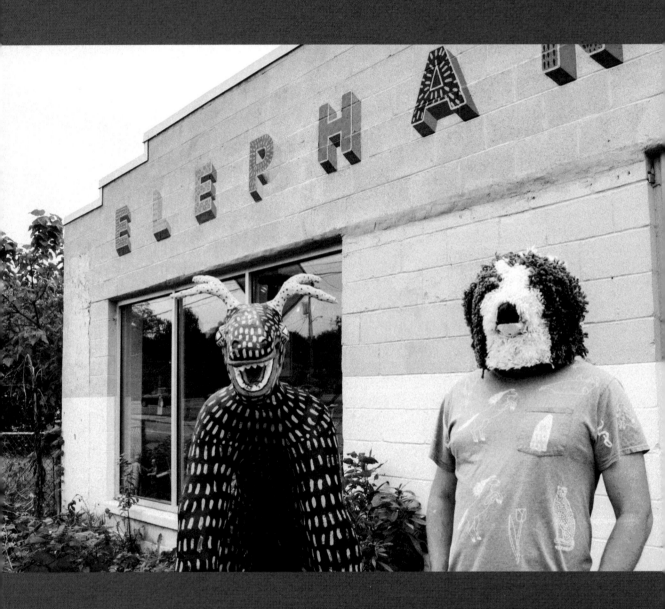

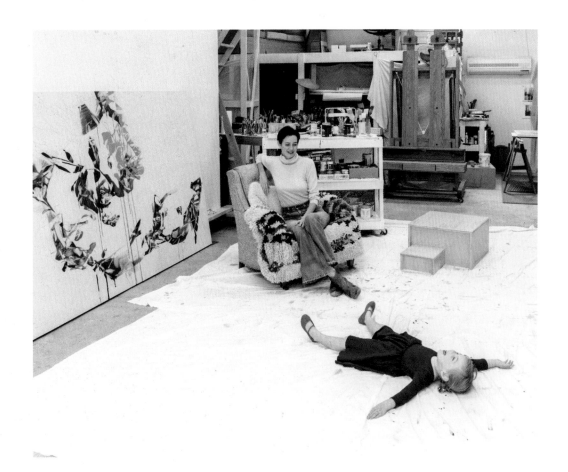

OPPOSITE: Alex Lockwood founded Elephant Gallery, curates
the shows, and builds his own pieces out of recycled packaging.
He brought the art crowd to the Buchanan Arts District.

~

ABOVE: Emily Leonard paints the flora and fauna of Middle
Tennessee. She and her daughter are shown here in her studio.

RIGHT: Moon Pie at the Parthenon, a full-scale replica of the original structure in Athens, Greece, that was built in 1897 for Nashville's Centennial Exposition.

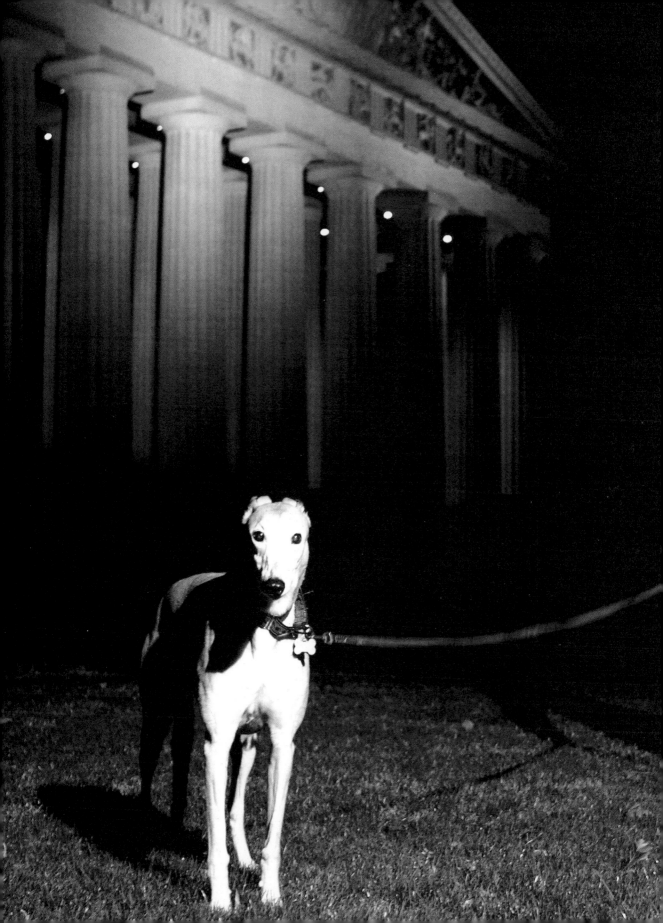

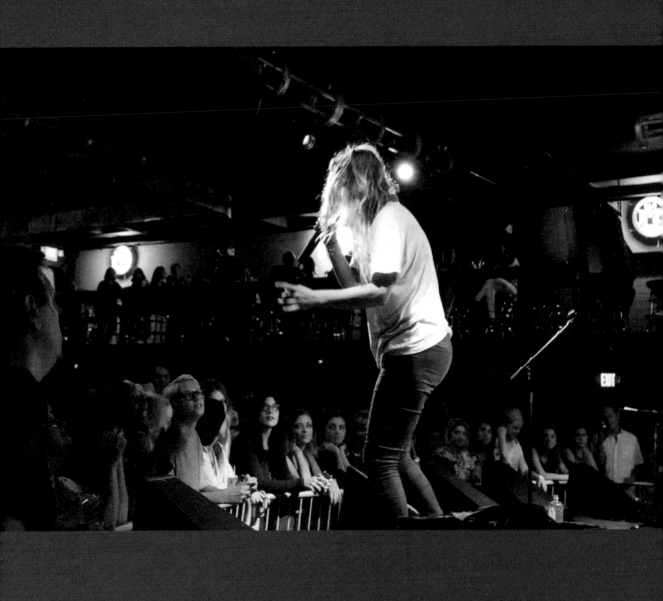

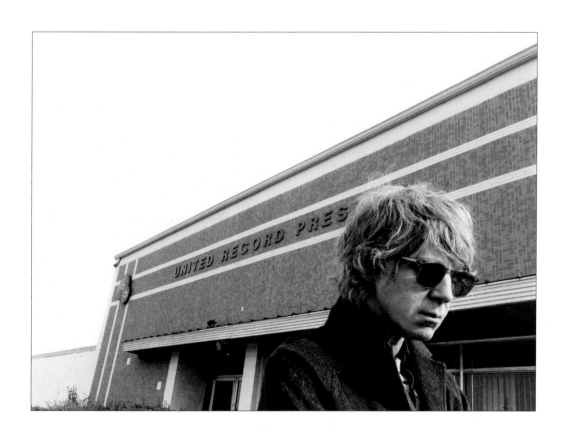

OPPOSITE: Lissie onstage at
3rd and Lindsley.

~

ABOVE: Wilco's Pat Sansone
outside United Record Pressing.

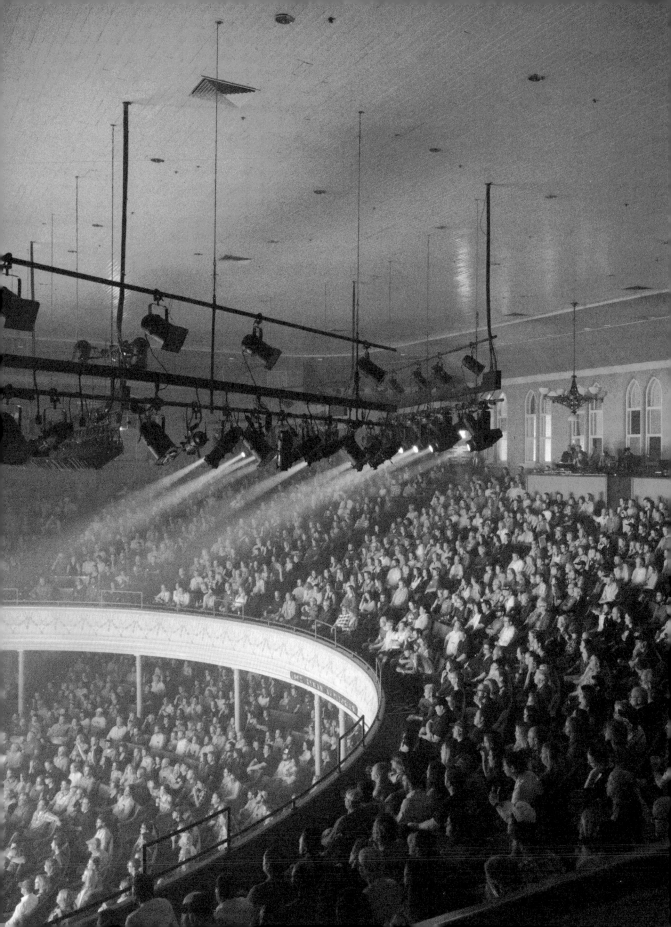

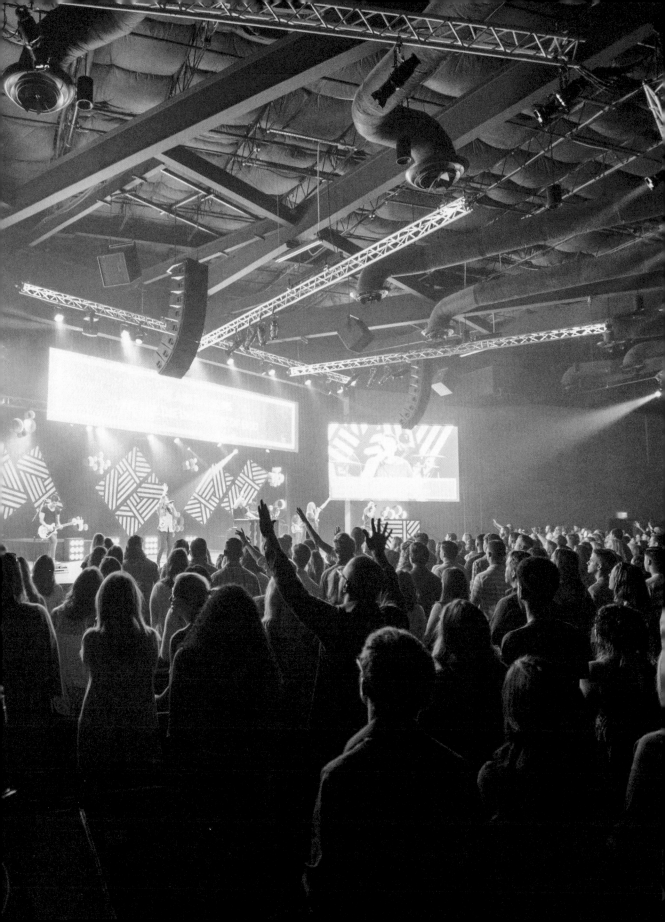

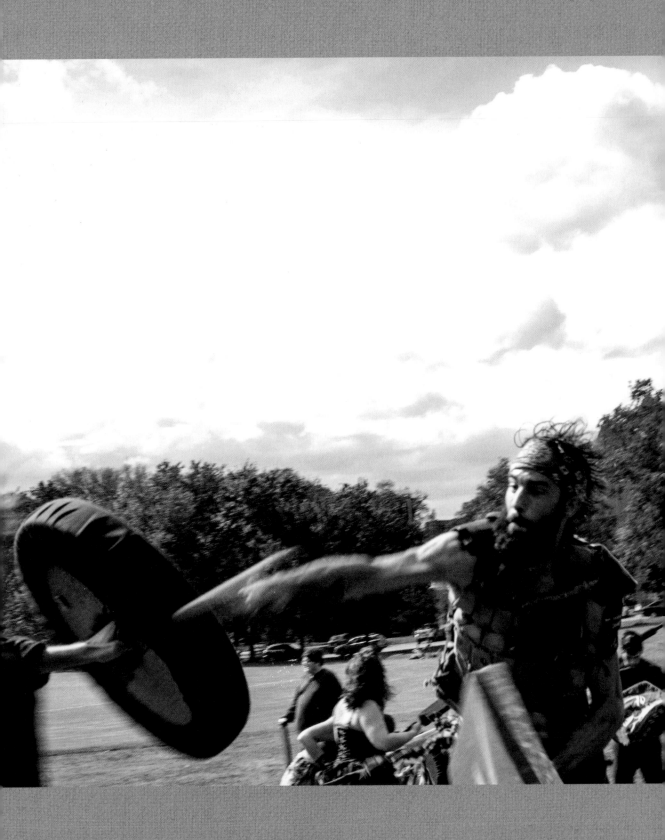

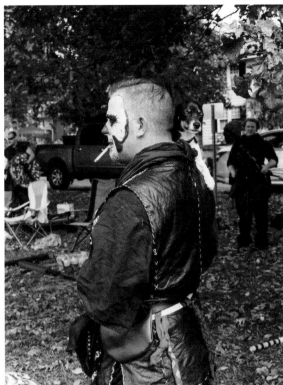

PAGE 168: Mother Church of Country Music, the Ryman Auditorium.

❧

PAGE 169: Tennessee has more mega-churches per capita than any other state in the country.

❧

LEFT: On weekends, Dur Demarion, the largest foam-fighting group in the South, gathers at Elmington Park, the lawn in front of West End Middle School, to wage battle.

❧

ABOVE: The dog's name is Squire.

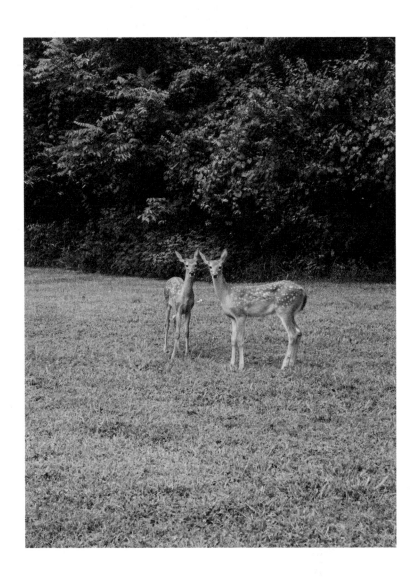

ABOVE: Fawns on the golf course at Shelby Bottoms Park.

⌒

OPPOSITE: Guarding the music, East Side Collective.

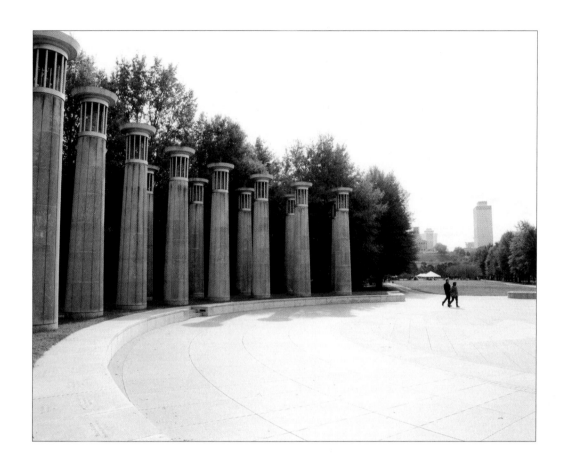

OPPOSITE: Nashville's convention center, the Music City Center, is 2.1 million square feet smack in the middle of downtown.

~

ABOVE: The bell towers in Bicentennial Capitol Mall State Park not only chime every hour, but when called upon, can also play "Rocky Top."

OPPOSITE: The *Blue Pesher* structure
at Cheekwood Estate and Gardens.

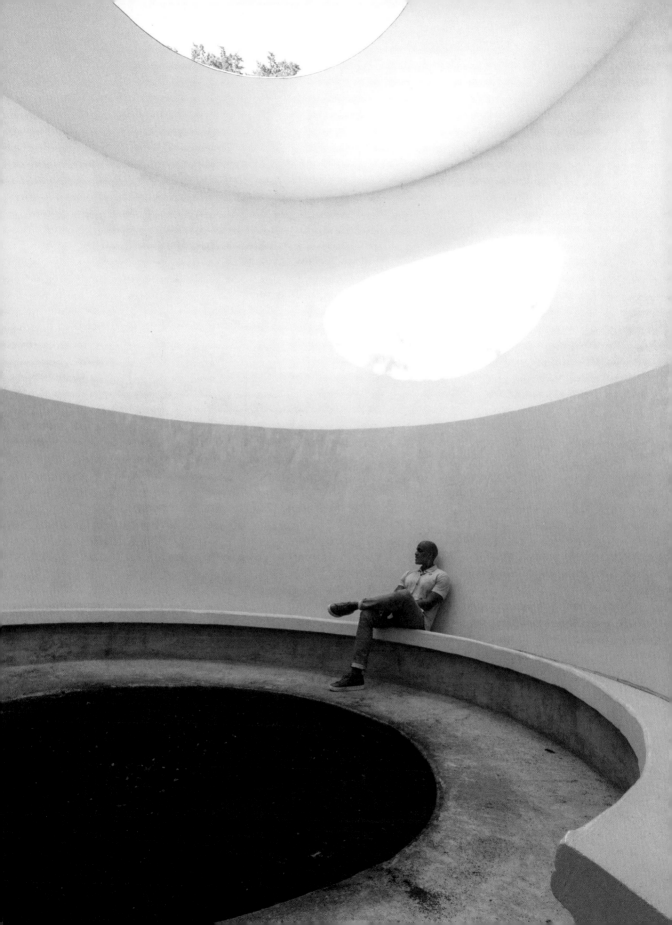

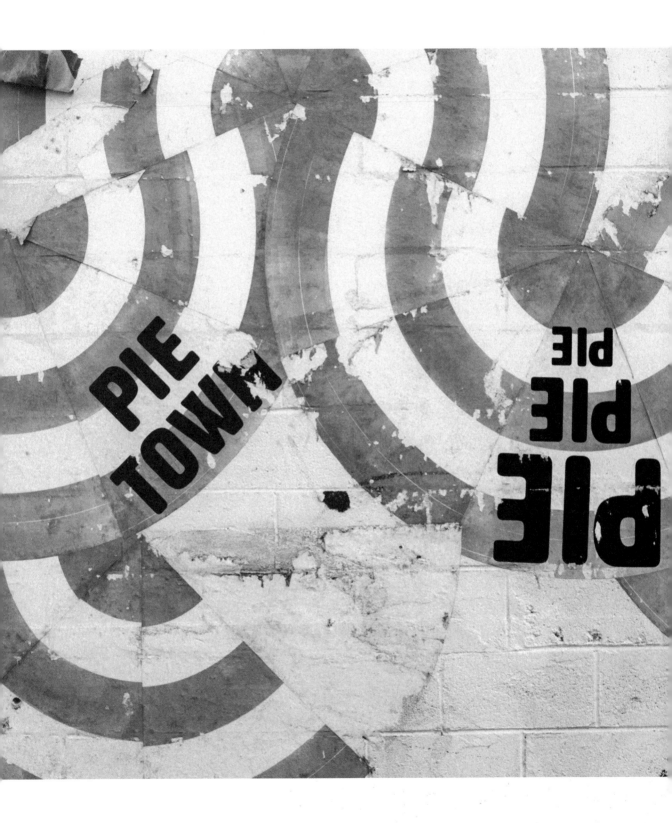

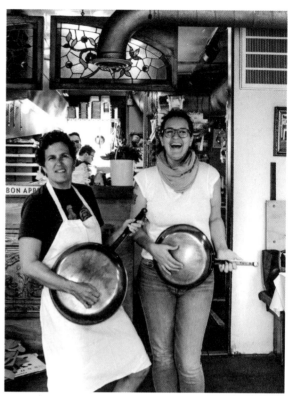

LEFT: Developers tried to call this pie-shaped Nashville neighborhood SoBro (South of Broadway). The neighbors insisted on calling it Pie Town. The neighbors won.

~

ABOVE: Chefs Margot McCormack (left) and Lisa Donovan. Margot pioneered fine dining in East Nashville with Margot Café & Bar, then followed up with Marché Artisan Foods across the street. Lisa has been the head pastry chef at Margot, Husk, and City House.

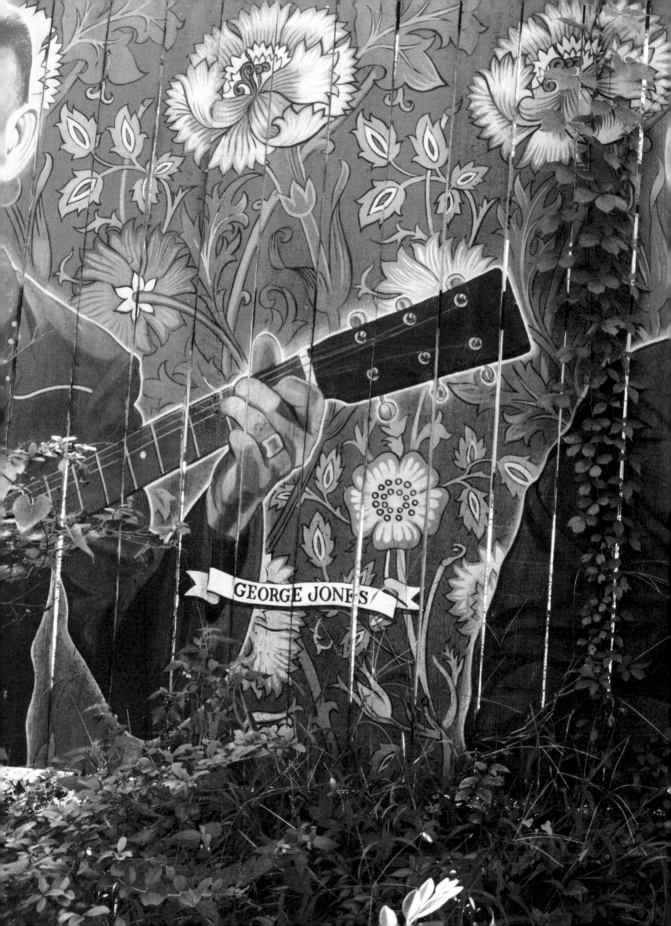

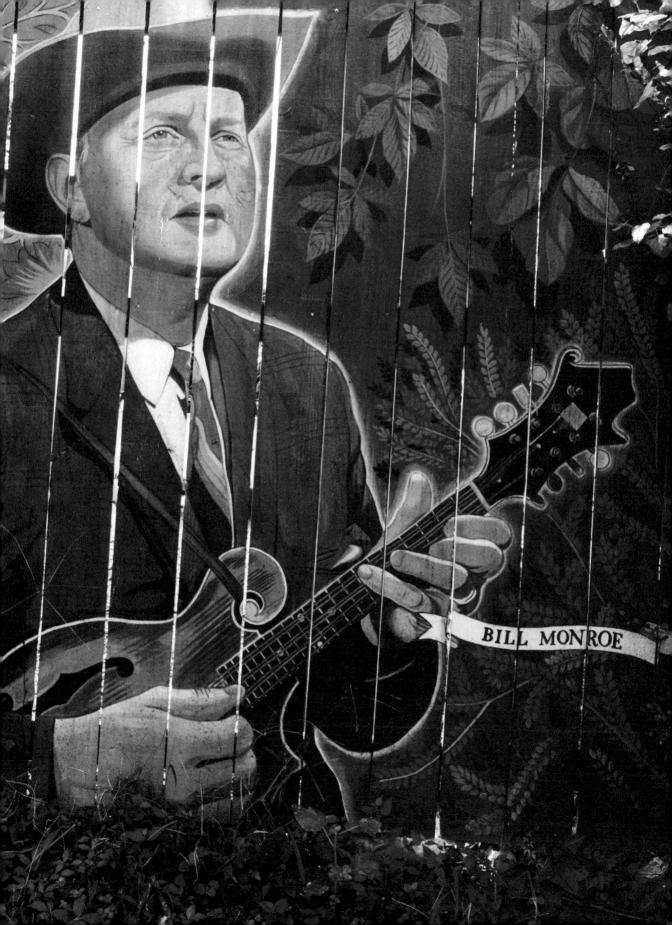

PAGES 180-181: Bill Monroe in Berry Hill.

∽

OPPOSITE: Music Row recording session,
Studio A.

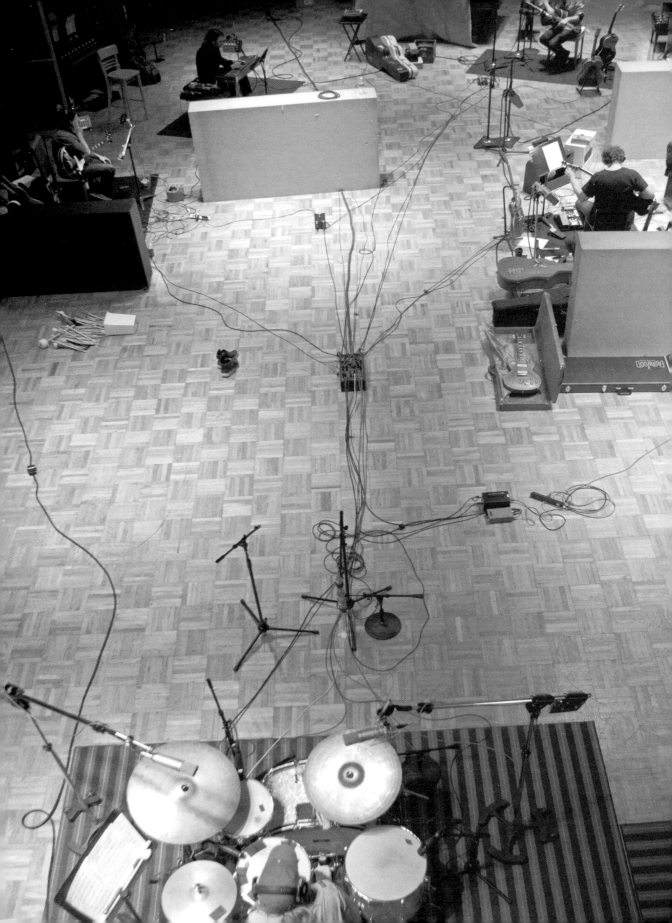

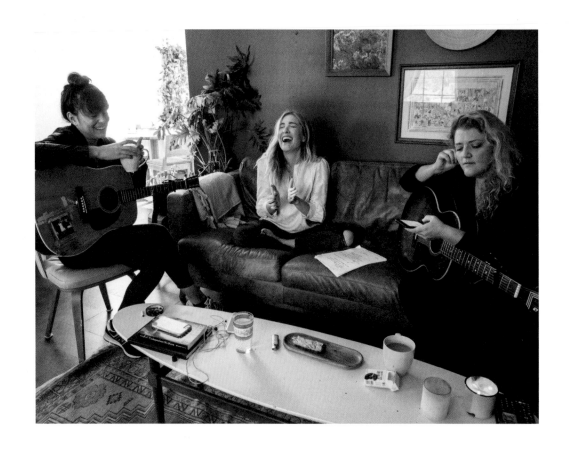

ABOVE: Madi Diaz, Sarah Buxton, and
Kate York in a songwriting session.

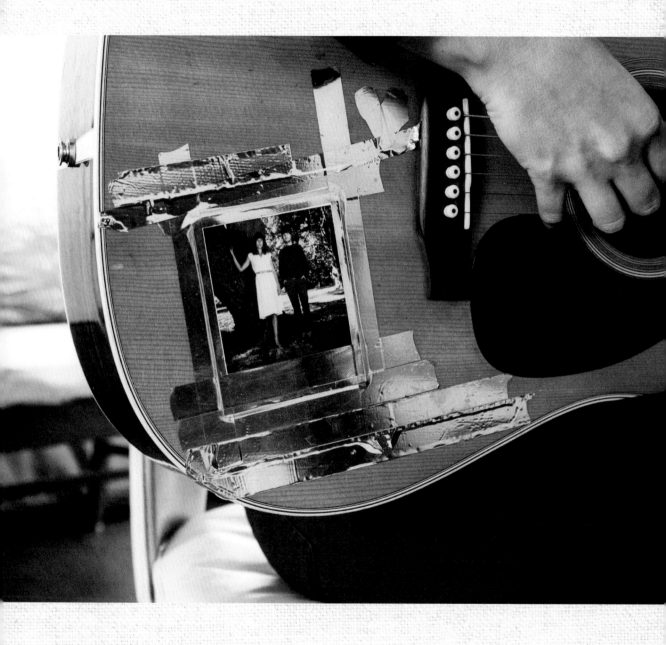

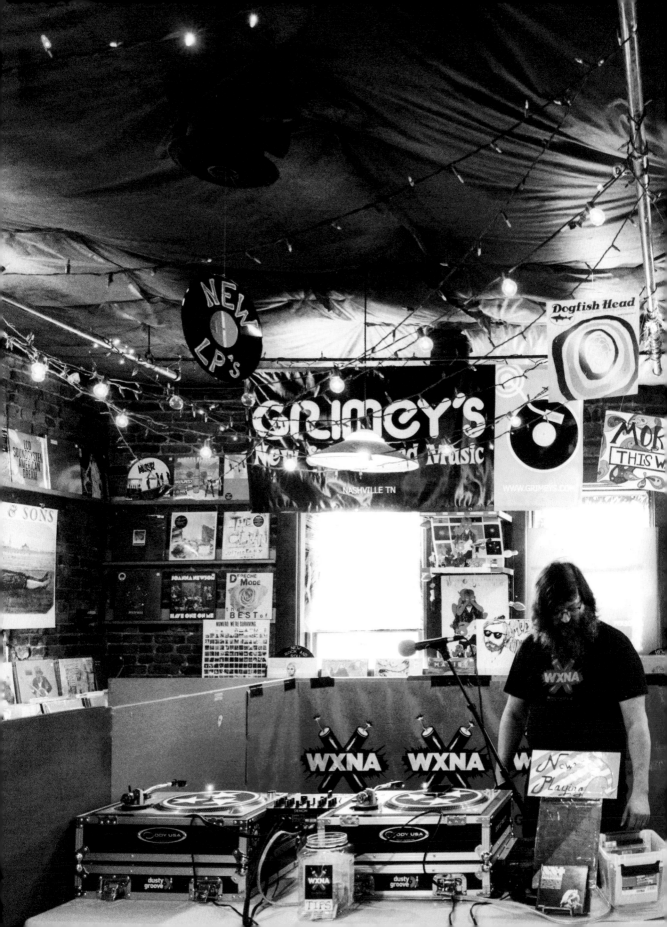

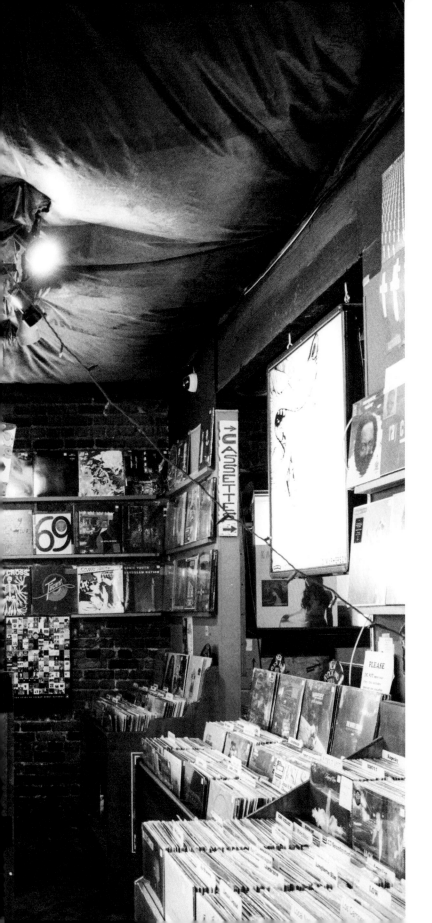

LEFT: Grimey's never gave up on vinyl, and so vinyl came back.

RIGHT: The iconic Delbert McClinton in the iconic Union Station Hotel.

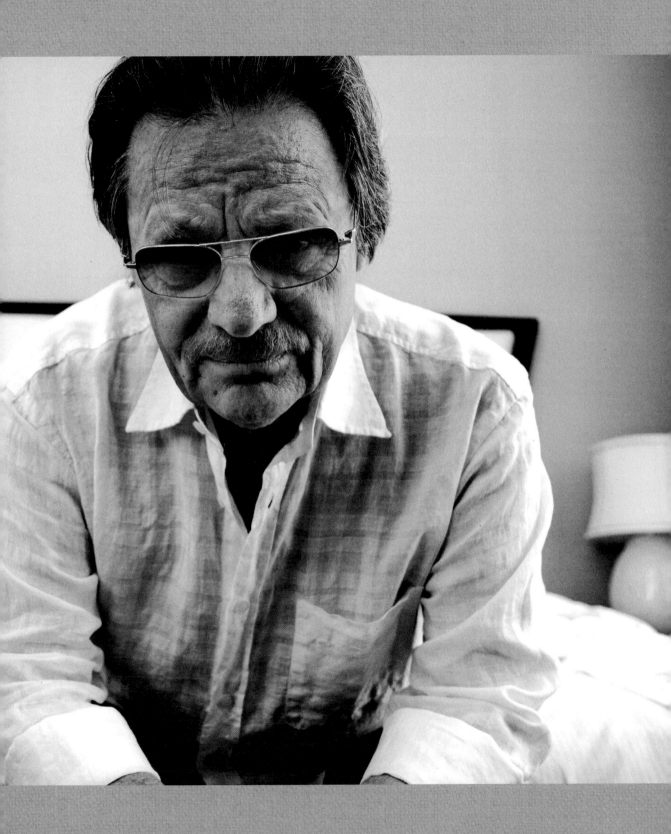

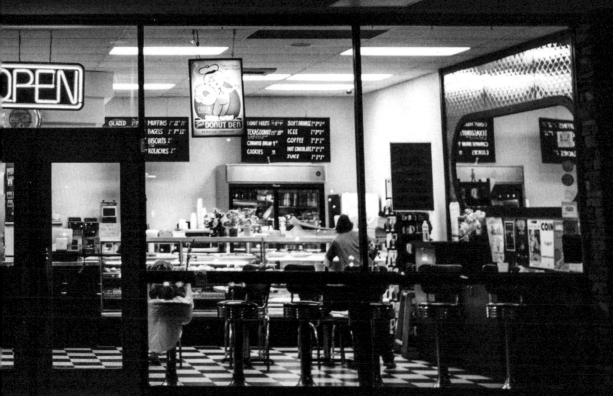

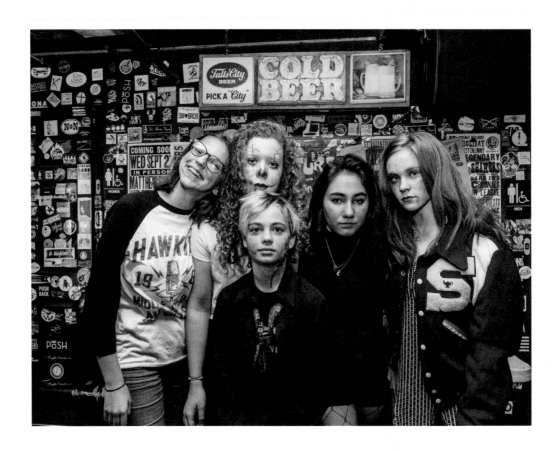

PAGES 190-191: Fox's Donut Den is where high school kids go after play practice lets out at 10:00 P.M. They pretend they're in New York.

෴

ABOVE: Queens of Noise is an all-girl, all-under-eighteen punk band.

෴

OPPOSITE: The Station Inn used to be a bluegrass joint in a crummy neighborhood on 12th Avenue South. Now the Station Inn is a bluegrass joint in the glamorous Gulch neighborhood. The Station Inn never moved. Proprietor J. T. Gray presides.

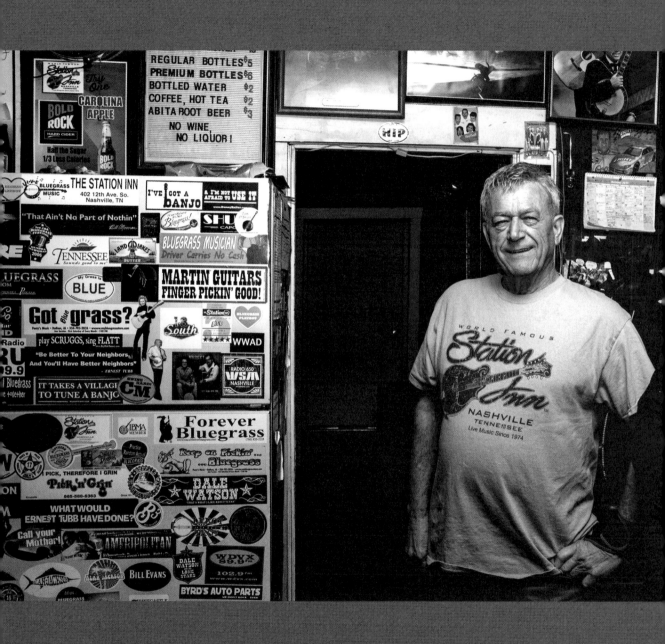

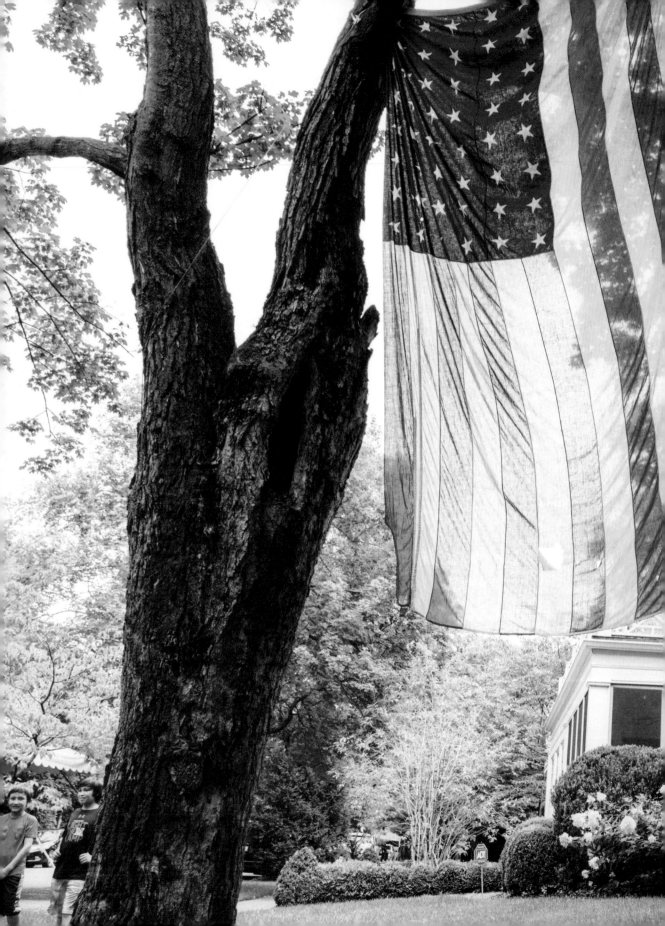

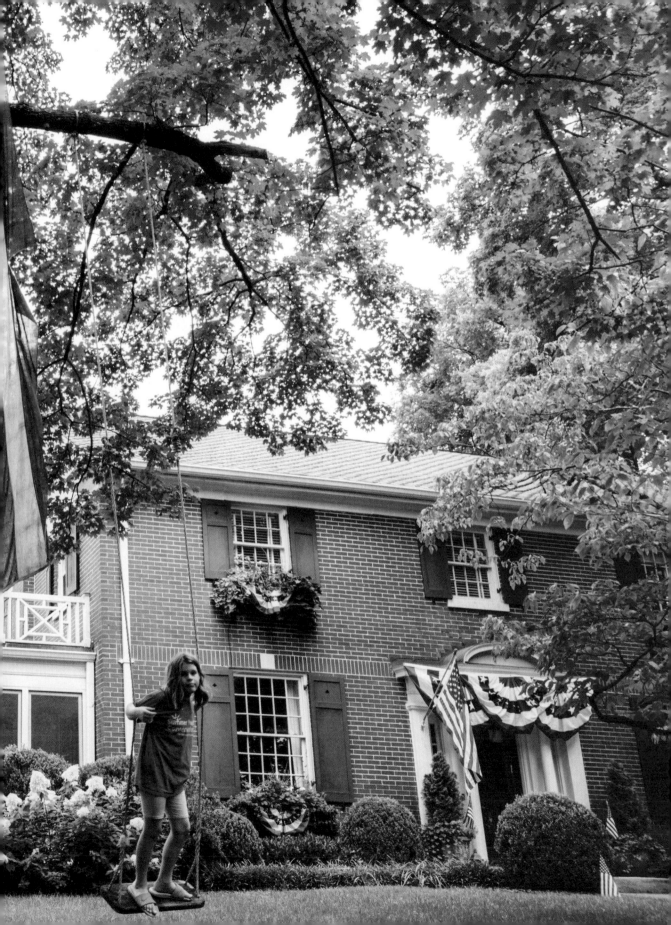

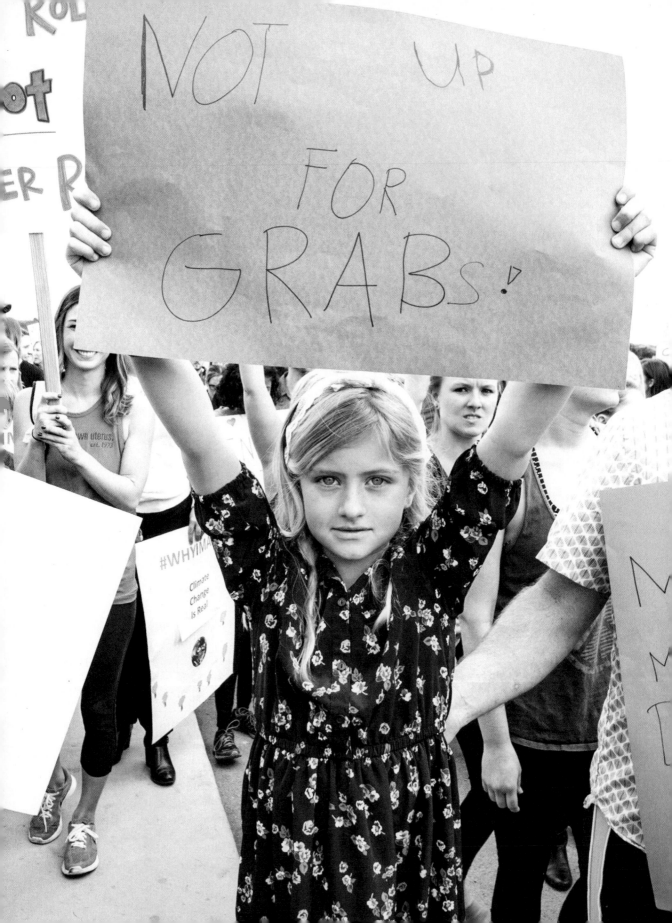

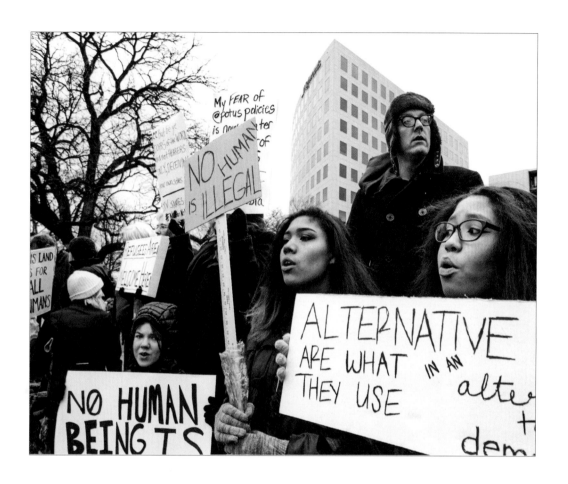

PAGES 194-195: Watching the Fourth of July parade on Whitland Avenue.

~

OPPOSITE: Fifteen thousand people participated in the Women's March in Nashville on January 21, 2017.

~

ABOVE: "No Ban, No Wall" protestors in front of Senator Bob Corker's office on West End Avenue.

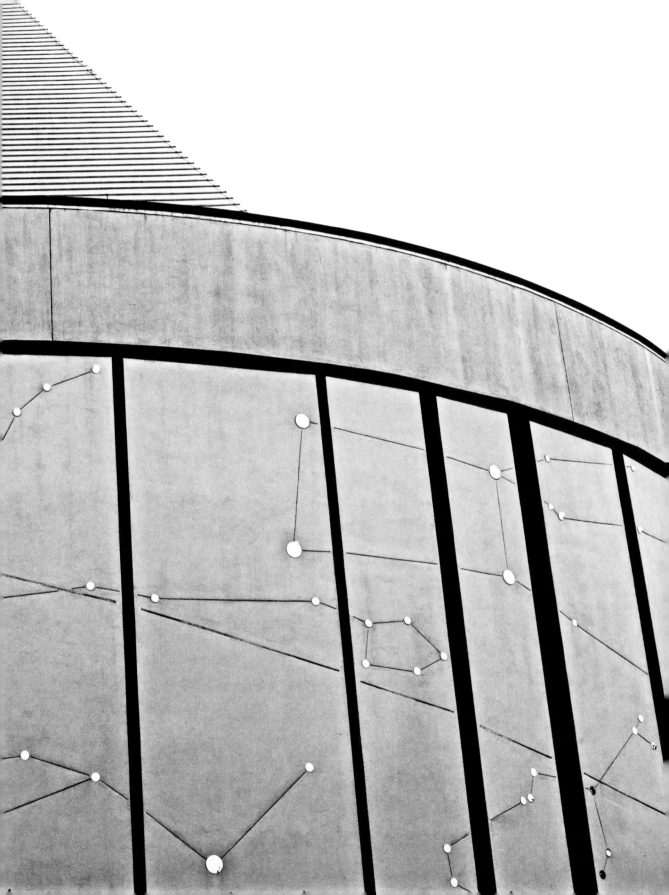

PAGES 198-199: Opened in 1945 as the Children's Museum and now called the Adventure Science Center, this museum has always been dedicated to bringing the world of science to kids—and the best place to take them when it's raining.

~

OPPOSITE: Supermodel and songwriter Karen Elson with her cat, Fergus. She is an ambassador for Save the Children.

~

PAGES 202-203: The End is a tiny club where many bands—REM, the Kills, Sleater-Kinney, and others—played before they were big enough to play at midsize clubs.

~

PAGE 206: Magnolias in bloom, Centennial Park.

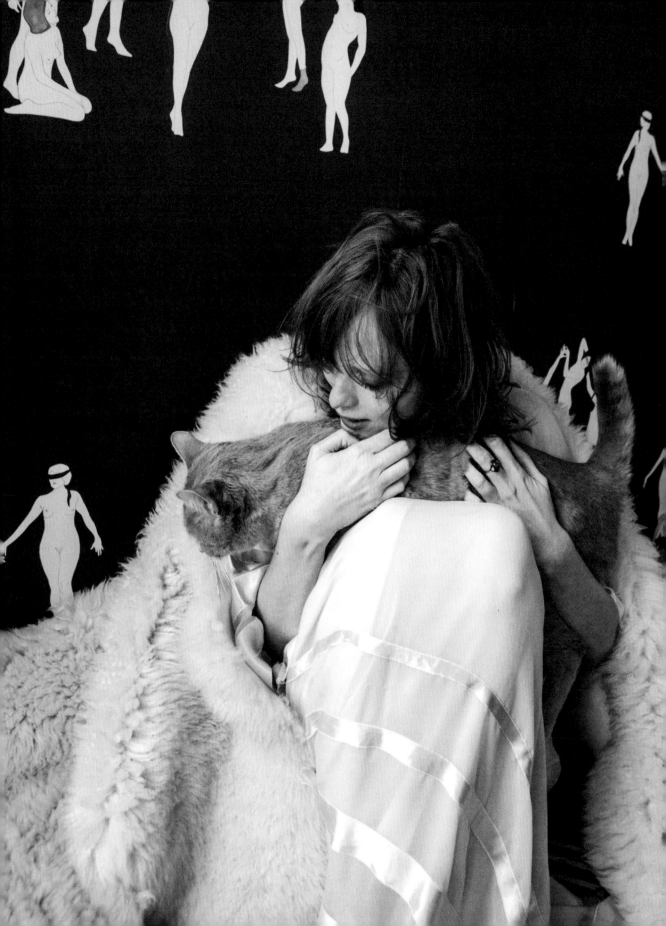

ABOUT THE CONTRIBUTORS

JON MEACHAM received the Pulitzer Prize for his 2008 biography of Andrew Jackson, *American Lion*. He is also the author of the *New York Times* bestsellers *Thomas Jefferson: The Art of Power*; *Destiny and Power: The American Odyssey of George Herbert Walker Bush*; *American Gospel: God, the Founding Fathers, and the Making of a Nation*; and *Franklin and Winston: An Intimate Portrait of an Epic Friendship*. Meacham, who teaches at Vanderbilt University, is a fellow of the Society of American Historians. He lives in Nashville with his wife and children.

ANN PATCHETT is the author of eight novels and three works of nonfiction. She is the winner of the PEN/Faulkner Award, England's Orange Prize, and the Book Sense Book of the Year, and was named one of *Time* magazine's 100 Most Influential People in the World. Her work has been translated into more than thirty languages. She is the co-owner of Parnassus Books in Nashville, Tennessee, where she lives with her husband, Karl, and their dog, Sparky. annpatchett.com.

HEIDI ROSS is a creative director and photographer whose work has been featured in group shows alongside William Klein, Richard Avedon, and Vivian Maier, as well as on album covers, book jackets, and in branding campaigns. Her work has been featured in the *New York Times*, *Vanity Fair Italia*, *Town & Country*, *Rolling Stone*, the *Wall Street Journal*, *Bloomberg Business*, *The Guardian*, and *Interview*. She lives in Nashville. heidiross.com.

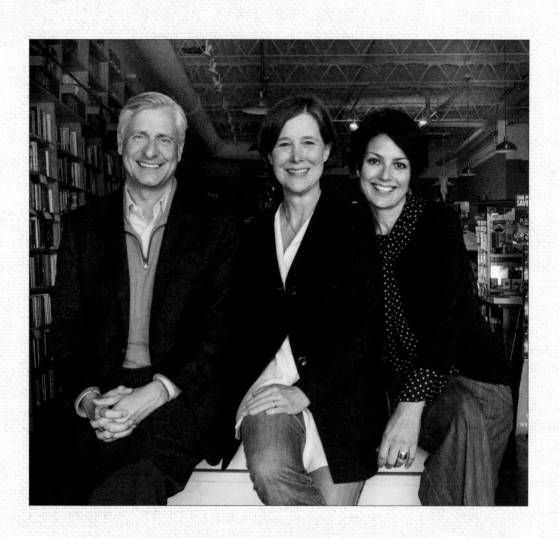

ACKNOWLEDGMENTS

Deepest thanks to Elizabeth Sullivan at HarperCollins who
came up with a great idea for a book about Nashville and gave
me a call, and to all the people and dogs at Parnassus Books.
—Ann Patchett

To everyone who said yes: my endless thanks and amazement;
with extra gratitude to Mark Nash and Jenn and Adam Raspler,
for going above and beyond.
—Heidi Ross

NASHVILLE

HarperCollins books may be purchased for educational, business, or sales promotional use. For information please e-mail the Special Markets Department at SPsales@harpercollins.com.

First published in 2018 by
Harper Design
An Imprint of HarperCollins*Publishers*
195 Broadway
New York, NY 10007
Tel: (212) 207-7000
Fax: (855) 746-6023
harperdesign@harpercollins.com
www.hc.com

Distributed throughout the world by
HarperCollins*Publishers*
195 Broadway
New York, NY 10007

ISBN 978-0-06-282144-7
Library of Congress Control Number: 2017947957

Book design by Tanya Ross-Hughes
Printed in China
First Printing, 2018

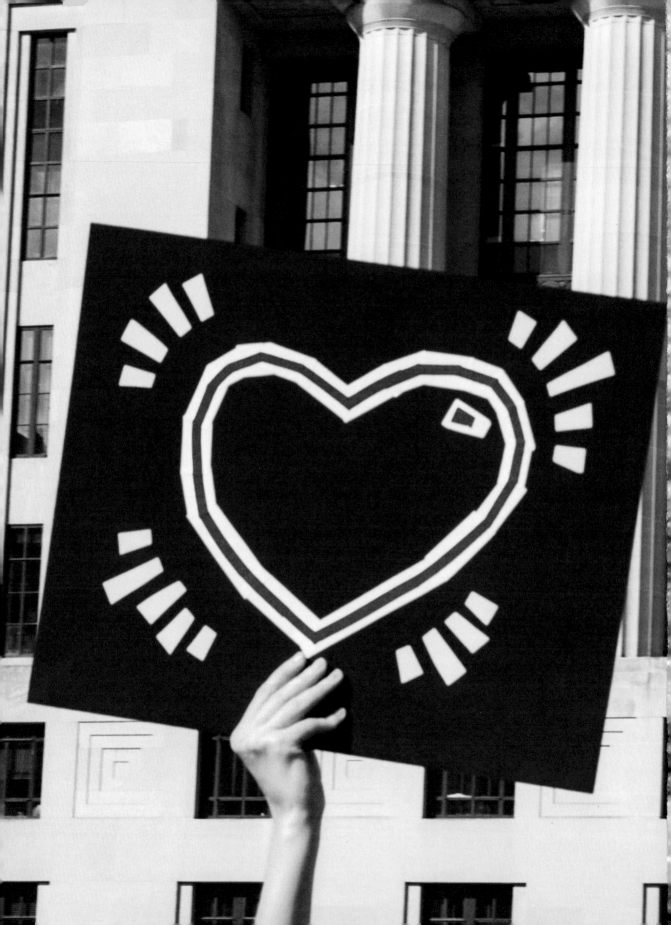